PRAISE FOR DENISE OSBORN[E]

"Salome is an interesting and refreshing lead character.... The story [] ill feel the po[]"

ser.com

"A frie[] did.... The F[] ade to come []"

Globe

DATE			

"Osbo[] *ned To Kill*]..

issouri

"A ne[] d fol- lower []y, it make []ter- hous[]"

:om

"My [] rk- able []cts Wat[] er- ent []"

ews

BAKER & TAYLOR

Evil Intentions

ALSO BY DENISE OSBORNE

QUEENIE DAVILOV MYSTERIES
Murder Offscreen
Cut To: Murder

FENG SHUI MYSTERIES
A Deadly Arrangement
Positioned To Die
Designed To Kill

Evil Intentions

A Feng Shui Mystery

Denise Osborne

PERSEVERANCE PRESS / JOHN DANIEL & COMPANY
PALO ALTO / MCKINLEYVILLE // 2005

A PERSEVERANCE PRESS BOOK
Published by John Daniel & Company
A division of Daniel & Daniel, Publishers, Inc.
Post Office Box 2790
McKinleyville, California 95519
www.danielpublishing.com/perseverance

Book design by Eric Larson, Studio E Books, Santa Barbara
www.studio-e-books.com

10 9 8 7 6 5 4 3 2 1

LIBRARY OF CONGRESS CATALOGING-IN-PUBLICATION DATA
Osborne, Denise.
 Evil intentions : a feng shui mystery / by Denise Osborne.
 p. cm.
 ISBN 1-880284-77-4 (pbk. : alk. paper)
 1. Private investigators—Washington (D.C.)—Fiction. 2. Japanese Americans—Crimes against—Fiction. 3. Georgetown (Washington, D.C.)—Fiction. 4. African American men—Fiction. 5. Feng shui—Fiction. 6. Novelists—Fiction. I. Title.
 PS3565.S374E94 2005
 813'.54—dc22
 2004011709

To Chris Osborne

for always being there

and to my mother,

Alberta Barker

Acknowledgments

EVEN SUCH a solitary endeavor as writing a book is not without collaborative efforts. The author must thank the following librarians for their assistance: Michael Anderson at the Mid-Continent Public Library in Lee's Summit, Missouri, for securing research material on illegal immigration and Chinese tongs/gangs; Jim Tellefson and June Hayashi at the San Jose libraries and Gayle Farthing at Scotts Valley Library in California.

Thanks to Alberta, Harrison, and Diane Barker; to Dee Osborne, Judy, Steve, and Phil; to Sandra Johnson of Philadelphia for supplying the details of the exquisite Chinese desk. For our special friendship, Kathryn and Tony Gualtieri in Capitola, California. Additional thanks to Gayle and Joe Ortiz and the Women of Mystery.

For Feng Shui information, the author is grateful to Professor Lin Yun, Feng Shui master and spiritual leader of the Black Sect Tantric Buddhist Feng Shui School; Cathleen Richard, owner/consultant, Feng Shui Wisdom; Mahdu Brodkey, owner/consultant, Feng Shui Reflections; Gabrielle Alizay of Homepeace; Nancy SantoPietro, consultant/educator and author of *Feng Shui: Harmony by Design* and *Feng Shui and Health*. Special thanks to Dennis Fairchild, one of Feng Shui's bright lights.

For editorial guidance and bringing the work forth, the author gratefully thanks Meredith Phillips. Thanks also go out to John and Susan Daniel for welcoming the author to their publishing

house. For their efforts at the very beginning, a special thanks to Samantha Mandor and Don Gastwirth.

Mike and Marilyn Fitzgerald in McLean, Virginia, must be thanked for providing a roof overhead. Many thanks to Marilyn for our glorious excursions around Georgetown, Washington, and through Virginia, and especially our time at Randolph-Macon Women's College in Lynchburg, Virginia.

Special thanks to dynamic Lydia Contreras for publicity, to M. Cochran for discussing her work as an organizer, and to RMWC alums Dolly Cardwell and Sally Boswell-Ware.

For their unique contributions the author thanks Sally Hintz-Huber; Carol and Greg at Vleisides Donnelly & O'Leary, LC; Steve and Alison Patterson; Charles Ferruzza and Carol Bardo at KKFI; and The Writers Place in Kansas City, Missouri.

While this book is a work of fiction and all characters creations of an active imagination, all material concerning the practice of Feng Shui is, to the best of the author's knowledge, factual.

Every house, every dwelling has a pulse, the pace determined by those who live and have lived within. Every structure has a character dictated by the thoughts and feelings of past and present residents. Most importantly, the nature of the dwelling, its overall impression of good or evil, positive or negative, is created by human intentions.

—Salome Waterhouse
Feng Shui Casebook I, Murder Houses

It is easier to denature plutonium than it is to denature the evil spirit of man.

—Albert Einstein

Even as a ghost My spirit will want to roam The fields of summer.

—Katsushika Hokusai
(traditional seventeen-
syllable haiku)

—THE BAGUA—

FAME

LI
RED

RELATIONSHIPS

FIRE EYES

KUEN
PINK

WEALTH

HSUN
PURPLE HIPS EARTH

WIND

ORGANS

CHILDREN / CREATIVITY

FAMILY / HEALTH

METAL

DWEI
WHITE

JEN
GREEN FEET

MOUTH

WOOD

GEN
BLUE / GREEN

MOUNTAINS

CHYAN
GRAY / BLACK HEAD

KNOWLEDGE HANDS

KAN
BLACK

HEAVEN

HELPFUL PEOPLE / TRAVEL

WATER EARS

CAREER

◄ THE MOUTH OF CH'I ►

Evil Intentions

Prologue

THE ORGANIZER'S body hung from a metal rod in the basement of the single-story house in a quiet neighborhood in McLean, Virginia. *Livor mortis* was evident beneath the fashionable midcalf-length trousers, the feet and ankles purple with the blood that had settled after death. Though there was less blood in the dangling hands and wrists, they looked equally dark in contrast to the brilliant white blouse worn outside the trousers. Hands and feet sported polished nails: toes red, fingers clear, none chipped or broken.

From the cocked head, fine precision-cut black hair fanned out across the left shoulder. The tongue protruded between red, bow-shaped lips. The makeup was perfect except for the lipstick smear where the full lower lip pressed against the upper part of the chin. The once-brown eyes were turning cloudy as conjunctiva dried. Neither bladder nor bowel had voided, and the body would be discovered well before decomposition had sufficient time to foul the air. In death as in life, the Organizer looked neat and carefully groomed and still smelled of that morning's shower.

Like the rest of the house, the basement reflected the single resident's natural inclination toward—or obsession with—cleanliness, neatness, and organization. Anyone not giving her death much thought would consider it a fitting place for such a person to end her life. Or to have her life end.

Chapter One

EIGHT DAYS AGO...

Germaine Brilliante gripped the steering wheel, straining to see the gravel road ahead. Whether on low or high, the headlights merely reflected light off the wall of rain, the effect similar to pointing a flashlight at a mirror in a dark room. Flowering dogwoods rose up on either side of the narrow track, their contorted branches bundled in pink-and-white blooms. During the day the trees no doubt epitomized the glory of the season, but on a rainy April night they appeared menacing, particularly when she thought of hitting one.

At the moment, she wished she and the others hadn't been so quick to agree to June's offer of the carriage house as a meeting place. June had remodeled the building, located well back from the main house and used for half a century to store the supplies and equipment used by a squad of gardeners, just so the group could have a special place all its own.

Middle-aged and single again, June lived with one servant in the twelve-bedroom Spring Hill Farms mansion where any number of rooms could have accommodated the monthly meetings. But, like everyone else, Germaine had simply agreed to the offer, succumbing as they'd all done to June's persuasive personality. No one said no to June McGann. Germaine wondered if by providing a home for the group—an expensive one at that—June believed the members would think twice about not attending meetings or even dropping out, that all would feel a greater obligation

to perpetuate what had begun years ago at Randolph-Macon Women's College in Lynchburg, Virginia.

She felt a sudden desire for a smoke and almost reached for the glove box and the pack of "just in case" cigarettes within. At least, thinking of a calming drag reminded her that she needed to breathe. The pack had not been opened for six months. Resolved not to give in to the urge, she gripped the wheel more tightly.

"Good-habit rabbit, good-habit rabbit," she muttered, conjuring an image of her mother's beatific face, hearing her soft voice whisper from the past, *Good-habit rabbit. That's my little Germaine.* Her mind switched to the sound of her father's baritone, projected from the grave, a voice honed over years in courtrooms. Perversely, he would point out that if she were that good there would be no cigarettes in the car at all.

The road meandered, the car squeezed by the darkness and thick foliage, and pounded by the rain. She wasn't certain how much farther she'd have to travel hunched over the wheel, her forehead nearly touching the BMW coupe's windshield while squinting at the flat sheet of light. Time and distance were suspended on June McGann's vast McLean, Virginia, estate.

The cell phone in her large black handbag trilled "Hark to the Chimes." No way was she going to take a hand off the wheel to answer the call. The clock on the dash glowed the time: 8:16. She had a feeling the caller was June making sure Germaine was on her way. Always impatient, June would not be as much concerned about Germaine's welfare as that she had taken care of business and hadn't forgotten to bring the information. Should Germaine's car be wrapped around a tree, most likely June would be less worried about her than about what she was bringing to the meeting—rather, bringing to show *after* the meeting when the others had left.

Germaine's years as an investigative reporter for various newspapers, the notables being the *San Francisco Chronicle* and the *Washington Post,* had ended six months ago, when the hot flashes, abrupt mood swings, and assorted annoyances associated with

menopause began to affect her work. The movers and shakers in business, politics, and entertainment no longer interested her; digging into their ambition-driven lives was no longer fun. Though once fulfilling, the work had also destroyed two childless marriages. *Can't talk now, John/Mark. I've got an important story to investigate/write/file.*

The built-in stresses of the job must have exacerbated the symptoms of menopause because once she'd quit, the flashes cooled, the mood swings transitioned more smoothly, and she began to look at men again—with sex and permanence in mind. But now in her fifties, she was probably too late. The physical improvement notwithstanding, she felt lonely and useless, one of the reasons she had agreed to June McGann's proposal and two weeks ago had begun following June's sister April.

At first she'd been shocked by the offer and asked why June didn't hire a private investigator. June had argued, "Look, your investigative reporting skills translate perfectly to the job. The only difference is, you won't be writing about your findings," emphasizing the latter. "We've been friends forever. I trust you to keep this quiet."

Though she hated to admit it, Germaine knew the McGann fortune had as much to do with it as June's friendship—the sum greater than one of its parts. Enormous wealth packed its own wallop. The substantial retainer gave her a sense of financial security she had not felt since the paychecks stopped. Maybe June had counted on that all along.

Tonight she would file her first report. Coming to another bend in the road, Germaine maneuvered the car to the right. Had the rain increased in intensity—or was she simply nervous about June's reaction? If she didn't like Germaine's work, would she fire her? And if so, Germaine might no longer be welcome at the meetings.

Rolling her bunched shoulders, Germaine wondered if her concerns stemmed from something she had discovered about June herself, old baggage June must have carried around for years but of

which she might not be consciously aware. Germaine had begun to believe that June was jealous of April. She couldn't fault her sister's looks, so she demeaned her intelligence. June had said of her eldest sister, "April is not the brightest bulb in the chandelier."

But even now, entering her sixties, April McGann was still a beautiful woman, managing to turn the heads of much younger men. Like her mother, a fabled beauty of Spanish and French descent, April was a natural blonde with contrasting dark eyebrows and large golden brown eyes, and had the well-maintained figure of a much younger woman. Germaine had bought a membership in the gym April frequented and had seen her working out in shorts and a sports bra. Less willing to display her body, Germaine wore sweatpants and a long-sleeved T-shirt and mainly walked on the track that circled the open area filled with treadmills and body-building machines.

In sharp contrast to her gorgeous sibling, June looked more like her father: tall and rangy with an overly large head and short gray-blond hair. Though never tagged a beauty, June had always carried herself well, never shying away from her height. Since their first meeting in college, Germaine had considered June formidable in both appearance and character, but now observing April, she could see how difficult it would be to have a sister who so exemplified female beauty. Comparisons must have been made from the get-go.

Then, too, there was the matter of the properties. June inherited Spring Hill Farms, but April got the Tres Soeurs estate on the other side of the Potomac River just off the Palisades; a showplace for all of its years, and a venerated Washington landmark. Certainly, Spring Hill Farms was nothing to sneeze at, but the Tres Soeurs mansion embodied style and glamour, assuring membership among Washington's elite. If June and April held parties on the same night and invited the same people, June would most likely be stood up.

Germaine's eyes darted to the right, where she sensed rather than saw the front of the main house. No lights shone from the

interior to reassure her, but its hulking, shadowy presence told her she didn't have that much farther to travel.

She took a deep breath, hoping to muster confidence and enthusiasm, and glanced quickly at the leather briefcase on the floor in front of the passenger seat. Inside were assorted eight-by-ten glossies developed and printed in the darkroom set up in her Crystal City apartment: April entering and leaving various expensive shops, day spas, restaurants, and cafés in Georgetown, and the most recent, a photo taken today on Wisconsin Avenue. In the lens, Germaine had caught April as she hesitated in front of a typical Georgetown town house just before disappearing down a set of steps below street level, furtively checking to see if anyone was watching. This was the first time she'd acted in a suspicious manner. A moment later, Germaine had trotted across the street and looked down on narrow steps that led to a single door. At first she thought it must be a basement apartment, then she noticed the lettering on a pane in the door: BLACK FRIAR'S BOOKS.

Recalling what happened next, some of that confidence she'd been mustering disappeared. Without thinking out the situation, Germaine had entered the bookshop. Big mistake. As she opened the door a bell jingled. Immediately, she'd stumbled over a raised piece of carpet, and struggling to keep her balance, barreled right into April. April dropped a book she'd just plucked from a shelf by the door.

Germaine apologized, silently cursing herself.

"Everyone does that. You'd think Mr. Friar would fix the carpet." She'd stooped to pick the book off the floor. About fifteen feet away, a gray-haired man sitting behind the counter peered at them, then bowed his head, apparently reading a book in his lap.

Straightening, April nodded toward the man. "Ask me, I think he enjoys seeing people trip."

Germaine moved off. She was furious with herself. April had made her. She should have stayed outside and come back at another time to see what April's interest might be in the out-of-the-way, postage-stamp bookstore.

Hardly a bustling enterprise; she wondered how Mr. Friar paid his rent. On offer were largely out-of-print editions of nonfiction history, political science, and travel books. Wandering down the narrow aisles and perusing the shelves while keeping an eye on April, she noticed a set of Will and Ariel Durant's *The Story of Civilization*, dust jackets in fine condition. She pulled out the volume on the Reformation. A first edition, no less. Mark, her second ex, had carted off her set when he moved out and she'd never replaced them. She considered buying the books, then reminded herself of the real reason she was even in this tiny bookstore. Returning the book to the shelf, she looked over at April only to find her quarry gone. Germaine moved up and down the aisles until she came to the counter. She hadn't heard the bell above the door ring.

"Excuse me," she said. "Do you have a rest room I might use?"

"We don't offer that accommodation," the gray-haired man said.

"Preferred customers only?" Germaine remarked.

He frowned.

"The woman who was here, I gather she's gone to use the rest room."

He blinked, his expression vacant.

"The blonde?" Germaine prompted.

"If you gotta go, I suggest you get going. Café across the street's got a bathroom but you'll have to buy somethin'."

Always an impetuous spender, Germaine blurted, "How about I buy that set of Will and Ariel Durants?"

"Be glad if you did." He stood and disappeared through a door to his right.

"May I use the rest room?" Germaine called out.

A moment later he returned carrying a cardboard box. Brushing past her, he said, "Be my guest."

"Through that door?"

"Uh-huh."

Germaine entered a dimly lit, narrow passageway. She tried

the nearest door. It opened onto a bathroom with sink, toilet, and stacks of boxes but no April. Further on and past a jumble of cartons, stacks of magazines, and cleaning supplies she found a set of stairs, the treads grooved and polished by years of wear. Germaine climbed to the top where a door barred further progress. She tried the knob but it was locked. She pressed her ear to the door but heard no sound from the other side.

Back at the counter she offered her credit card and asked if she could return later in the afternoon to pick up the books. He agreed. She thanked him for the use of the bathroom.

"Just out of curiosity, do you know the blond woman who came in just before me?"

After a moment he said, "Yes," guardedly.

"She looked familiar."

He relaxed a little. "Should do if you're from around here."

"I didn't see her leave." Germaine shrugged. "Funny that the bell didn't ring."

He busied himself with the credit card machine, seemingly not paying any attention to what she was saying.

Still, she pressed on. "You live upstairs?"

"You ask a lot of questions."

"Goes with the territory. I'm—I used to be a reporter."

He started, his face actually registering fear. He handed over her credit card and spoke quickly. "Sign here. Store closes at five. You can bring your car to the alley round back. Press the buzzer and I'll bring the books."

She mumbled a thanks, his offer just another reminder that she no longer looked physically capable of carrying anything heavier than a handbag. God, she hated getting old.

After a final twist in the road, Germaine saw a watery light above a wide carriage door. A golden glow outlined the shuttered window to the right.

Germaine pulled up alongside Mary Booker-Manheim's economy car, a ten-year-old model as no-nonsense as its owner. She

shut off the engine, and reaching behind the seat, grabbed the ugly yellow oilskin rain hat and pulled it down over her newly cut hair. She collected the briefcase, her purse, and a heavy plastic bag from a photo shop that contained a carousel of slides.

For a moment she stared out the window weighing the pros and cons of reporting today's fiasco at Black Friar's Books. April's disappearance from the shop proved the first clue that the woman might be up to something. Unfortunately, it also called into question Germaine's competence. Now that she'd arrived she changed her mind about the clubhouse, realizing it really was the perfect meeting place. As part of the remodel, the double carriage doors had been painted glossy crimson. The single window on the ground floor and dormers thrusting from the upper loft were double-glazed and all sported a pair of black shutters. The slate roof was brand new.

Though the main house had any number of rooms from which to choose, it lacked the element of exclusivity, which along with privacy, the carriage house provided. Germaine now realized that the carriage house, long used as storage for gardening supplies, harked back to their original clubhouse, an abandoned gardeners' shed far from the dormitories and classrooms housed in the venerable buildings of Randolph-Macon.

Then, beyond the shimmery curtain of rain, she saw the narrow door open. A tall figure stood silhouetted against the bright light within. June. Germaine's shoulders twitched with a sudden chill and she realized the back of her blouse was wet with nervous perspiration. No question, she would inform June of *everything*. After all, it's what a good-habit rabbit would do.

Chapter Two

"*YOU'RE LATE,*" June scolded. She wore a black wool pantsuit with sheared beaver lapels on which was pinned a mono-grammed *JM* platinum brooch.

Germaine noticed the tension in her jaw and neck and on the edges of her spiritless smile. The other four women lingered around the fireplace sipping from highball or sherry glasses, their chatter accompanied by Vivaldi.

The women had been drawn to each other, as young people of like mind are, during their freshman year in the late 1960s. SOW, pronounced "sew" as in "you reap what you sow," was an acronym for "Stewardship of Women." They saw themselves as purveyors of social justice, crusaders for the underdog. Though some people called them "sows"—as in female pigs—they were too zealous to be bothered. Over Christmas and Easter breaks, they volunteered at the Salvation Army and soup kitchens and drove through rural southern Virginia handing out food packages bought with their own money. During their junior year abroad, each young woman immersed herself in the local culture, seeking out the needy even when her help was unwelcome and seen as just another form of American aggression.

They settled petty disputes among classmates and were gener-ally respected for being sincere and fair-minded. Upholding Randolph-Macon's reputation for academic excellence, all twelve of the original SOW members graduated in the top ten percent of their class.

After college, naturally enough, members dispersed to pursue individual goals. Over the years some, but not all, showed up at class reunions, where talk always got around to the resurrection of SOW. Then, at the most recent reunion, some of the women found that they were living in the D.C. Metro area or close enough to drive to monthly meetings. They discussed possible meeting places, then June offered Spring Hill's carriage house.

To the left of the hearth, Mary Booker-Manheim, gray hair pulled back in her trademark bun, leaned against the mantel. Ruth Chastain, reed-thin and six feet tall, stood a head above her companions. On the right, Abigail Delahay-Cross fingered her usual strand of pearls. Maureen Placer-Coe, her huge amber eyes looking somewhat vacant above flushed cheeks as if her attention was internal, stood beside Abigail and wore a navy blue dress, the dark color and style designed to camouflage fifty extra pounds.

Graduates of women's colleges were likely to tack a husband's surname to their maiden name. It was a way to recognize friends after marriage. Upon divorce, it was common simply to drop the added surname.

"Sorry, everyone," Germaine apologized to the group after setting her things on the antique deacon's bench, hanging her coat and hat on the already filled coat rack, and fluffing her hair.

June tapped the briefcase and raised her eyebrows. Germaine nodded. June then spun around and clapped her hands. "Let's go on in to dinner." To Germaine she said, "Pour yourself a sherry from the drinks cart and bring it in if you like. We're all starving."

"Amen to that," Maureen said, following the others into the adjacent dining room. She reached out and squeezed Germaine's arm. "Like the hair cut."

"Thanks."

The space where carriages, and later, expensive automobiles were once housed, now served as a dining room complete with a sideboard loaded with steam trays. The original brick floor had been painted a pleasant shade of green.

At the polished mahogany table set for twelve, in honor of the original group, the six women found their place cards. The scent of a hickory log burning in a small fireplace whetted appetites even further. An array of silver cutlery flanked the plates; crystal water goblets and wineglasses headed each place setting. Candles flickered in the draft as Larsen, June's housekeeper, wheeled in a cart loaded with covered stainless steel trays, which she lowered onto the steam bins set up on the sideboard. Larsen made another trip to the anteroom, returning with a large wooden bowl heaped with fresh salad dressed in a raspberry vinaigrette and crumbled blue cheese, and a chocolate cake.

"Something smells delicious," Ruth said, turning in her chair to address the housekeeper. "How are you this evening, Miz Larsen?"

"All the better for your asking, dear," Larsen said with a quick smile. She made certain there were enough dessert plates, then excused herself, leaving through the front door.

Over the salad course, they chatted about assorted ailments and remedies. "Toss the pills," Ruth remarked. "Walking. Now that's the best overall cure for everything." Given Ruth's height and graceful stride, Germaine flashed on a vision of giraffes moving across the savannah.

"Yoga," Abigail said. "Remember last year I told you I'd lost an inch in height? Had a physical last week, and *Voilà!* I've gained a half inch back! Has to be the yoga."

Over fresh grilled salmon, potatoes au gratin, steamed yellow squash, and homemade rolls, talk turned to professional considerations. Ruth was retiring soon as partner in a large D.C. law firm. Next month, Mary, a social anthropologist who had worked at the Smithsonian for years, was heading to Australia to visit her daughter and family. June, responsible for maintaining the McGann fortune, suggested that they hire an organizer as she had recently done.

"The woman is priceless," June gushed. "By putting my house in order, she's putting my *life* in order. Every drawer, every cabi-

net. Started on the office today. That'll be the real test, it being
such a god-awful mess."

"I could use someone like that," Germaine said, breaking open
a steaming roll. "What's her name?"

"Honey. Honey Lee. Chinese woman. And she speaks fluent
English."

"What does she charge?" Germaine asked.

"Out of your league, dear."

The others stopped eating momentarily.

Germaine's face stung and her jaw clenched. "I'll be back on
my feet soon enough."

To deflect the barb, Ruth interjected, "Jim and I could have
used help like that when we were married. With three kids, and
both parents working full-time, our house was always a disaster.
Who knows, we might not have divorced if there had been pro-
fessional organizers back then."

Abigail smiled at Germaine. "Why don't you write a book
about all the people you've investigated over the years? It would
be a bestseller."

"I'd only be rehashing old news. And besides, I need the frenzy
of a pressroom to write. Quiet and isolation drive me nuts."

Maureen, publisher of Christian-themed romances, who usu-
ally offered news about the vagaries of publishing, remained un-
usually quiet.

With chocolate cake came confessions.

"I've met a man," June said, her expression more haughty than
amorous. "A *gentleman*, actually. He was at Gordonstoun with
Prince Charles and is now a knight of the realm."

There were a few murmurs of admiration.

Ruth moaned. "Do us the courtesy of sending a list of things
you'd like. You have no idea how hard it is to shop for wedding
gifts for you. We've all had to do it four times already."

"I said we'd *met*, Ruth."

Then Abigail said, "Is he cute?"

Silence fell.

"What?" Abigail lowered her fork.

Germaine burbled until the suppressed laughter could no longer be contained. The infectious sound spread. It was difficult to imagine someone like June involved with a "cute" man.

"Ladies, please!" June said, though her stiffness had softened. "Cute? Middle-aged men are rarely cute."

"At best they are preserved," Ruth added.

"Actually, he's *gorgeous*." June flushed, the sudden infusion of blood proof that this new man was indeed significant.

Ruth smiled. "Well, well. Haven't seen *that* look since college, when you and Vic Woodson were engaged."

There were a couple of gasps, then silence. Ruth had forgotten that Victor Woodson had dropped June soon after meeting her sister April.

"Have you had sex?" Abigail asked, in her own way resuscitating the conversation.

"Oh, please," June snapped.

"Is he rich?" Germaine inquired.

"As Croesus."

"Has anyone had sex lately?" Abigail said.

The room went dead quiet again. Then Maureen spoke. "I have."

Everyone perked up. "The old married couple," Ruth said. After a pause she added, "I'm assuming you do mean sex with Andy, right?"

"Of course."

"Well, go on!"

"Details, Maurie, educate us!"

"Actually, the most memorable part was after. That's when…" She stopped. Lowering her eyes, she seemed to be struggling for words.

Everyone felt the shift in mood.

Finally, after a deep breath, she went on. "That's when he told me he's in love, madly in love—with someone else."

A shock wave wiped all amusement from the women's expres-

sions. Ruth, sitting to Maureen's right, reached over and gently touched her shoulder. "A younger woman?"

Maureen shook her head, biting her lower lip, struggling again.

"Not a man?" June asked.

"Worse," Maureen said.

The women exchanged puzzled *What could be worse?* glances.

Maureen sat straighter and held her head up. "It's Melinda."

"Not *our* Melinda." Ruth's face registered absolute incredulity.

"Yes. *Our* Melinda," Maureen said with bitterness. She pushed her dessert plate away.

Shortly after SOW had regrouped, Melinda Hankins dropped out, with apologies, saying she just didn't have the time.

"How long has this been going on?" June asked.

"Since SOW started up again. The night of the celebration party at our house, to be exact."

"No wonder she quit," Abigail said.

"What are you going to do?"

"Me? I haven't a clue. At least the kids are grown up and off on their own. Still, it doesn't mean they won't be affected—something Melinda doesn't have to worry about. Andy said she told him she'd fallen in love with him at our wedding—twenty-five years ago—and that's why she never married."

"Bullshit!" June spat and pushed her plate aside. "She's always been too damn selfish to love anyone but herself. She's probably just feeling her age, getting lonely and targeted the first poor sod who couldn't run fast enough."

Sparks shot from Maureen's amber eyes. "Why do you call Andy a poor sod? Because he's had to endure twenty-five years married to an overweight purveyor of sappy romance?"

"I meant no reflection on you, Maurie."

"All these years you've probably felt sorry for him."

"Hey!" Germaine said.

"Has anything been resolved?" Ruth asked, and pushed her plate aside, too.

"He moved in with her the next day."

"And sex was your farewell gift. What a guy," Abigail said.

"You should have called someone. All of us," Ruth said. "That's why we're still friends after all these years. We're here for each other."

"That's why I came tonight, instead of begging off. To tell you all together so I don't have to repeat myself. It's something I have to come to terms with on my own. Hell, I publish books about these situations every day! God, if readers find out, this could really hurt sales."

Maureen rose from her chair and set the linen napkin on the table. "Forgive me for putting a damper on the evening, but I'd better go. As to business, just tack my vote to the majority."

June also stood and walked her out of the room. As she put her arm around Maureen's shoulder, the sobbing began.

"Excuse me," Abigail said, tears welling. She dashed out to join Maureen and June.

For a moment, the three women left at the table stared at the candles, their unfinished cake, anywhere but at each other. Then Ruth removed her dessert plate altogether, making more room for her long arms, which she folded on the table. In the posture of a conspirator, she leaned forward and spoke in a low voice. "Remember the Christmas meeting?"

Mary snorted ruefully. "Hell, I can't even remember last month's meeting."

"I know what you're talking about," Germaine said softly and she, too, moved forward in her seat. "I was just thinking the same thing. Maureen brought it up, said it was something one of her authors was researching for a book."

"For God's sake, what are you talking about?"

"The Star Chamber, Mary."

Mary looked at Ruth, then at Germaine. "Jesus! You're serious. Hold on here, SOW is about good works, not vendettas."

"Oh? Remember when those two freshmen in Wright replaced all the poems on the poetry tree with obscene limericks?"

Germaine reminded them. "Wright" was the campus dormitory where the intellectuals lived.

"Oh that. It was funny."

"Maybe now, but not then. They blasphemed a tradition. We voted to retaliate."

"And?"

"Oh, Mary, you really don't remember?"

"No, dammit, I don't."

"You and I got them drunk at some dive outside Lynchburg. Maureen and June drove them out to the stables—"

Mary's eyes brightened. "Of course! The Yellow Roses of Texas. Brought their horses to school. They woke up naked in the paddock, without eyebrows, and painted bright yellow. Now I remember. They were kicked out of school."

"I'd say that was retaliation," Germaine said.

"More a caper."

"They *were* kicked out of school. That's serious," Ruth added.

"And would have been anyway, if Administration had found out they were responsible for desecrating the poetry tree."

"*If,*" Germaine went on. "We did the investigating, Mary. We discovered the culprits. We determined punishment. We could have ratted on them. Instead, we took responsibility. So don't tell me we've never sat in judgment like a Star Chamber."

"The idea of it gives me the creeps. That was school. This is real life. Correct me if I'm wrong, but you're proposing punishing Andy Coe and Melinda Hankins, right?" Mary asked.

At that moment, June entered. "Don't you look like a guilty bunch. What did you do? Eat the rest of the cake?"

"How's Maureen?" Ruth asked.

"Not fit to drive. She'll be staying the night. Abby's with her now, so, if you're finished, let's take care of business. I have a presentation and so does Germaine. If everyone's amenable, let's keep the program short."

They trooped upstairs to the warm, homey loft with overstuffed chairs, exposed beams, and a crackling fire that Larsen

had laid earlier. June had decorated the room with field hockey sticks, Randolph-Macon Wildcats black-and-yellow banners and baseball caps, and framed photographs of their college years. Germaine retrieved the slide projector from a cupboard. June set up the screen. Ruth carried the urn of coffee and set it on a table already prepped with cups and saucers, spoons, cream and sugar, and a plateful of cookies. Once they were settled, June said, "Germaine, why don't you go first."

Germaine set a carousel of slides in the projector and the evening's business began.

Chapter Three

IN THE kitchen at the back of the main house, Louise Larsen, the housekeeper, turned off the faucet at the double sink. While wiping her hands on a dish towel she looked out the window at the rainy night. Her eyes swept up past the cars parked this way and that on the gravel drive fronting the carriage house to the second story. Even with the curtains drawn, she could see some yellowy light at the west-facing windows. She checked her watch. It was nearly nine forty-five and June's two friends were upstairs here, the one settling the other in for the night. When she glanced back at the carriage house, the windows were completely dark. Larsen felt a slight twinge of concern that maybe the electricity had gone out. But this had happened before. They probably showed a movie or something. More important to her was how long they would be. After she served dinner, Larsen was not allowed back in to clean up the dining room until the guests left. Other than an old zinc sink, the carriage house had no kitchen facilities. No matter what the hour, she would have to make several trips loading and unloading the trolley; the weather would make the task that much more unpleasant.

Larsen had worked for the McGann family for all but the first fifteen of her sixty-seven years. During that time she had never balked at nor protested any demand. June treated her in the same way she had as a child, expecting every request to be promptly and efficiently fulfilled, seemingly unaware that the once-heavy black hair had thinned and faded to gray, that the once-straight

36

back had bent, that the once-smooth, straight fingers were now gnarled by arthritis.

She had been shuttled over to June's McLean estate, Spring Hill Farms, last year when April McGann decided to change the household staff at the Tres Soeurs mansion. For over fifty years Larsen had lived and worked at Tres Soeurs and the move had been traumatic, though she had tried to bear the painful uprooting without complaint, always aware that a servant who brooded drew attention to herself and thus risked her job.

Larsen took a mug from the cupboard and went to the coffee-maker. Just as she began to pour, she heard someone enter behind her. Startled, she spun around, scalding her hand with the hot brew.

"Finished for now," chirruped June's organizer, Honey Lee. "Where Miss McGann? I say good night."

"Ms. McGann is busy," Larsen snapped, not bothering to hide her distaste for this unwelcome addition. In the month she'd been in June's employment, she'd organized nearly every room—every room, that is, but the kitchen. Larsen wouldn't easily relinquish her exclusive territory.

"Don't recall you carryin' a briefcase before."

"Only days I work in home office." Honey smiled. "Please. You look."

Honey set the briefcase on the counter, opened it, and moved to the coat closet beside the pantry. She wasn't worried. The briefcase contained only filing supplies. Next week, the tiny camera in her pants pocket would have what she needed: images of credit card and financial statements, June McGann's DMV license and her Social Security number. Her employer complained that she was taking too long. But this was a big house and it had taken time to develop June McGann's trust so she would let her into her home office. And of course, today being Honey's first day in the office, June had had to supervise. Next week, Honey felt certain, she would have the opportunity she needed.

Honey loved her job and was very good at putting people's

lives in order. In her two years as an organizer, she had never been dishonest. But she couldn't say no to the Snakehead. When he promised that this job would cancel her debt to him, she agreed to do it. It would save her years in paying off the rest of her passage from China to the United States. She would miss the pretty house she rented and the nice car, but most important, she would be free for the first time in the years since her illegal immigration.

Larsen closed the briefcase and handed it to the tiny Asian woman who stood before her still looking as fresh as when she arrived at three that afternoon, white blouse still crisp, black capri pants not carrying a speck of lint, the raincoat appearing as if it had just come from the cleaners. Her black shoes were as shiny as her precision-cut black hair. All of this only fueled Larsen's animosity.

Slipping the strap of a leather bag on her shoulder, Honey opened the kitchen door. "Good night," she said with a smile, and opened her black umbrella.

"Bloody foreigners," Larsen mumbled, though she, too, had once immigrated. But being of British extraction, she never considered herself a "foreigner."

Larsen watched Honey climb into her neat late-model car and drive off, then finished filling her coffee mug. After adding cream, she carried it to her book-lined sitting room off the kitchen. She only read nonfiction, and all her adult life, she had built up a collection of first editions. But hardback books were not easy to hold anymore and her eyes tired quickly. Whoever had come up with the idea for books on tape should certainly achieve sainthood, she thought, not for the first time, as she settled into her reading chair, coffee on the end table in easy reach. Just before switching on the tape player, she considered how to broach the subject of Lee without sounding like she was complaining. June put little stock in feelings, especially coming from staff. But Larsen's intuition was strong; it told her that Lee was a snoop and up to no good.

Leaving it for the moment, Larsen turned on the tape player and took a calming breath. As the tape unspooled, she listened to

the recorded version of *King Leopold's Ghost* by Adam Hochs-
child. Her mind drifted from household troubles to the woeful
events in the Belgian Congo during the late nineteenth century.
Absently, she rubbed her arthritic hands, listening to the tale of
how one European monarch's insatiable greed decimated the
population of a West African country. And didn't she know first-
hand how great wealth leached people of their humanity?

Back in the carriage house, the four women stared at the image of
the serene, benevolent-looking woman projected on the screen.
She wore a long black robe with a stiff Chinese collar, her hands
held palms-up at stomach level, the left above the right, thumbs
nearly touching. She stood in front of a grove of tall bamboo,
a concrete Japanese lantern to her left. All the elements of the
photograph, including the woman's features, bespoke Asia.

"This is Salome Waterhouse, the Feng Shui practitioner whom
Cookie Freeman wants approved to give a lecture at the Women's
Place," Germaine said from her position behind the slide carousel.
Germaine had been assigned to conduct the background investi-
gation, and because of her research even pronounced Feng Shui
correctly: *fung shway.*

The Women's Place was a halfway house in rural Maryland
they helped fund, and SOW was involved in vetting prospective
residents who were, for the most part, women trying to kick drug
and alcohol habits. Visitors were rare and required prior approval.
Before its recent incarnation, the house had been a battered wom-
en's shelter. But because of the need for more space, SOW had
purchased another much larger house in eastern Maryland to ac-
commodate battered women and their children.

"Where'd you get the photo?" Mary asked.

"Her publicist. Waterhouse's publicist, that is."

"If she's selling a book there's no way I'll approve her," Ruth
said.

"Don't jump to conclusions. The publicist books her speaking
engagements. She's very much in demand."

"What does she charge?"

"Irrelevant. She'll do it gratis. Cookie said she's the one who paid for the new roof last year. The anonymous benefactor."

There were some approving grunts and positive clicks of the tongue. Germaine pressed the remote and a new slide replaced the former. A color shot of a handsome town house appeared on the wall.

"This is her house in Georgetown. On Malabar Close."

"How about that," Ruth said. "We're practically neighbors. But I don't recall ever seeing her around. How long has she lived there?"

"Since her divorce seven years ago from Gabriel Hoya—for those who don't pay attention to the *New York Times* bestseller list, Gabriel Hoya is a successful mystery author. They were married for twenty years. She did his research. He lives in McLean."

"She didn't move very far," June commented.

"Partially correct. Waterhouse lives in Georgetown from March to October. She spends the rest of her time...*here*." Germaine clicked to the next slide. The house projected on the screen looked to have come from a book of fairy tales. It was a stone cottage with faux-thatched roof and a rounded red door one could imagine being opened by an old woman in a pointed hat flourishing a magic wand. Behind the house was a large body of gray-blue water and misty bluish hills beyond.

"Holyrood-by-the-Sea, ladies, and in the background Monterey Bay. Incidentally, these photos I got off the town's Internet site."

"Idyllic," someone murmured.

Germaine showed two more slides of the seaside village with its distinctive fairy-tale architecture nestled around an arced beach. "Though not quite as posh as Carmel, its neighbor some miles to the south, as you can see, the place is not without its charms. Waterhouse's grandfather was one of the founders and the family owns a lot of real estate in town."

"Would you show her picture again?" Ruth asked.

After a couple of clicks, Salome again appeared before them. For a while the only sound was the hum of the projector.

"She's Asian?" Ruth said.

"Her mother's second-generation Japanese, born in the U.S."

"Nisei," Mary added, correction implied in her tone. "And her name is Hebrew. Interesting."

"Father, Caucasian; the grandfather of Scottish descent. Who knows, the town might have been named after Holyrood Castle."

"Holyrood, a piece of the true cross," Mary piped in.

"Thank you, Mary. Anyway, Waterhouse studied with Grace Wu, an elderly Chinese practitioner who until recently lived near Dupont Circle. Madame Wu, as she's known, practiced Feng Shui in the Metro area for decades, long before it became fashionable in the west. She was very exclusive and very expensive."

Germaine switched on the lamp and gave the remote to June. June slipped several slides she'd taken from a small box into empty slots.

"Lights, please," June said.

Germaine turned out the light. The carousel rotated through several blank spaces until one of June's slides slipped in front of the light element and a professional head-shot of a pretty blond woman in her mid-twenties appeared on the wall.

"Susan Sawyer," June began. "She had just graduated from law school when this photo was taken in the mid-1980s."

"Good Lord," Mary blurted, "she could be your sister April's twin—well, years ago, anyway."

In a level voice, June said, "I think you'll find any resemblance ends here...."

The next photo elicited gasps and sympathetic murmurs. It was a police mug shot of the same woman, the left side of her face badly bruised, the eyes swollen shut and severely contused. Her top lip was spit and protruded over the lower lip. Her hair looked dull and matted.

"That's Susan Sawyer two months ago. Arrested for public drunkenness after a barroom brawl in Alexandria."

The photo dominated the room while June related an abbreviated history of how Susan Sawyer reached this point in her life.

"After law school, she clerked for a judge in Miami for a few years, then joined a small law firm devoted to women's issues. About ten years later, she married the son of the judge she'd originally clerked for and they moved to Fairfax, Virginia. He'd majored in political science at the University of Miami and got his law degree at George Washington University. When they married, he was of counsel to a Florida senator. She started drinking after her second miscarriage."

Germaine hardly heard a word, her own concerns louder in her mind than Susan Sawyer's alcohol-derived travails. June's comment, *Out of your league* played over and over, *Good-habit rabbit* supplying the chorus.

"...would be a good place for her to recoup." June paused. "Lights, please."

The room remained dark.

"Germaine! Lights!"

Startled, Germaine reached over and turned the lamp back on.

"Questions or comments?"

"Susan Sawyer's what? In her forties?" Ruth said. "She might have trouble fitting in. The other residents are under thirty, except Louvee, who clocks in at what, thirty-five?"

"There is that," June said. "But none of these women 'fit in,' as you say. The younger ones might benefit from Susan's experience."

Mary posed another question, this one rhetorical. "And how many of the others have a law degree and lived in a house in Fairfax?"

"Granted, the residents on the whole are from the streets."

"Sawyer has money," Ruth commented.

"Had. Her town house is in foreclosure. What little money she had she used for legal fees."

Mary turned toward June. "She's not related to you in some way, is she?"

"If you recall, Mary, I drafted the bylaws nearly forty years ago! Would I be unaware of the rule prohibiting SOW assistance to relatives? I don't think so." She took a deep breath. "A friend at a Falls Church social services center called Sawyer to my attention. Other than AA, she's never sought outside help. Anyone else?"

After a short silence June shut off the projector. The time had come to vote.

"Let's start with Susan Sawyer. Ruth?"

"Personally, I believe in second chances no matter what your age," Ruth declared. "I vote yes."

After all four women voted in the affirmative, June said that Abigail like Maureen had given June the authority to cast her vote with the majority.

"Right, then. SOW will absorb Sawyer's legal fees. Once a room is available she'll move into the Women's Place.

"As to the Feng Shui practitioner, Salome Waterhouse, proposed by Cookie Freeman to give a presentation—"

"Hold on a second," Germaine said, checking her notes. "I forgot to mention that she gave a Feng Shui presentation at last year's fund-raiser for the Women's Place that Cookie hosted at her restaurant. Apparently, it was a great success." She smiled and shrugged. "I wasn't here but I hardly think that would put the woman in a negative light. However, I did need to mention it."

Ruth responded with a look of concern. "Frankly, I'm of two minds about this. However, my problem is ignorance. I don't know anything about Feng Shui. As for Ms. Waterhouse, if I hear she used this Feng Shui as an excuse to proselytize, or convert anyone to some off-beat religion, I won't be happy or quiet about it. You can be sure of that. I may be retiring from the practice of law, but I still have the power to affect professional reputations. A charlatan will not be tolerated. With that disclaimer, I vote yes."

Mary went next. "I can't see any reason Ms. Waterhouse would translate the misfortune and weaknesses of others to somehow benefit herself. I say yes."

June spoke. "Far as I'm concerned, New Age practices are just

another way to separate one from one's money. If she were charging a fee, I'd definitely say no. But given her apparent financial independence, she's probably a true believer. I don't foresee any harm being done and therefore say yes."

Germaine said, "We have a majority in favor. Still, I'd like to add my two cents. I've heard Feng Shui is about taking care of one's environment and getting rid of clutter. If Ms. Waterhouse can get the residents excited about those two things, I'd consider keeping her on permanent retainer."

Germaine would call Cookie Freeman, who would then arrange a day and time for the presentation with Salome Waterhouse. "And frankly," Germaine added, "I'd like to attend the presentation."

June closed the meeting with a short prayer, blessing those less fortunate and thanking God for their ability to help others and for their continued friendship. She stood first and moved to the stairs, anxious to send the others on their way.

Mary began collecting coffee cups.

"Germaine and I will take care of clean-up," June said.

Ruth raised her hands. "Hold on a minute. I have an idea. But the decision will be June's."

June halted at the top of the stairs.

"Thing is, we have a sister who's hurting. I mean, really hurting. She needs to be with friends. So. Why don't we all stay and have an old-fashioned slumber party, like the old days?"

Mary brightened. "Great idea! Anyone have a hot date…? No, I didn't think so. Come on, June."

June and Germaine exchanged glances.

Arguing her point, Ruth continued, "Look, we help other people. But we have to be here for each other, too."

When June did not respond, Ruth shrugged. "If it's inconvenient, I apologize. It was just a thought."

Finally, June relented. "Why not? We haven't done anything impetuous in years. You can raid my newly organized dresser for nightgowns."

Their spirits elevated, the other women trotted downstairs chattering, recalling pillow fights and "pizza pig-outs" from their youth. Mary pulled out her cell phone and called her husband. June stayed upstairs. Germaine helped her friends with their coats, saying she and June would be over shortly.

Germaine spent a moment watching Ruth and Mary scamper through the rain. When she closed the door on their shrieks and laughter, a deep silence fell inside the house. With some reluctance, she mounted the stairs, the briefcase pulling heavily on her right hand.

June sat on one of the two chairs she'd moved to the fireplace. Germaine joined her in the other chair. Opening the briefcase, she removed a thick accordion file of clear green plastic and passed it over to June, who eagerly began scrutinizing the eight-by-ten black-and-white glossies.

"I arranged them chronologically, earliest in front, today's shots in the last slot. Tabs on each slot indicate the dates."

She might as well have been talking to herself. June would empty one slot, stare intently at each photograph, then toss it on the floor.

It wasn't long before June dropped the empty file, images of April McGann strewn at her feet.

Germaine looked at her expectantly. Still silent and seemingly unaware of Germaine's presence, June rose and went over to a cabinet under one of the dormer windows and pulled out a pack of cigarettes, a lighter, and an ashtray.

Germaine took a deep breath and gritted her teeth. June lit her cigarette without offering one to her companion, who, at the moment, would have gladly taken one.

"Burn them," June ordered.

"What?"

"You heard me. Burn them!"

Germaine rubbed her eyes, then stooped down and gathered all the prints, two weeks of work, the shots carefully selected from nearly a thousand negatives.

"While you feed the fire, give me a report," June said, staring out the window, remaining at a distance and subtly hinting at her distaste.

Automatically, Germaine reached in the briefcase for the little notebook. Just as quickly, she stopped herself. June had instructed her not to take notes, saying she wanted no written record of the investigation. Of course, thirty years of habit had taken over. At her age, she couldn't be expected to remember every detail over fourteen days. Besides, she had needed the notes to properly create an order for the photographs.

A sideways glance at June reassured her—June continued to stare out the window and hadn't seen the action.

Germaine turned over the pile to begin with shots of the first days of the investigation, the photographs tweaking her memory of each place April McGann visited on her predictable daily rounds.

"Today, though, she changed her pattern," Germaine said, and watched the last of the photographs blister, then blossom into flame.

"Today, then. What happened today?"

Germaine took a deep breath. The good-habit rabbit made its appearance.

Including her ignominious entrance, Germaine detailed her experiences at Black Friar's Bookstore, concluding with Mr. Friar carrying the twelve-volume set of *The Story of Civilization* to her car. She was just about to add the most tantalizing detail of all, when June interrupted.

"Well, I hope you don't expect the books to be part of your expenses. The gym membership, fine. But not the books."

Germaine responded with quickly mustered coolness. "I was simply glad to have found them and never considered them your expense." She went on. "As I was about to tell you, after Mr. Friar put the books in the trunk, he suggested that I make no more inquiries about the blond woman who had preceded me in his shop."

"That's all he said? You didn't question him further?"

"I asked him why. He ignored me and went back in the shop."

June lit a second cigarette with the first, speaking between puffs. "Tell me, Germaine, while you were following April did you ever, *ever* see what Abigail would call a 'cute' man? A man with, um, slightly Asian features?"

"You mean, like Salome Waterhouse has Asian features?"

"Yes, subtle. Very attractive."

"Well, I certainly saw a lot of Asian people. Look June, why don't you tell me what this is about?"

June's eyes telegraphed something odd, something that made Germaine very uneasy. Germaine looked away, into the fire, then back at her friend. *Friend?* The woman at the window did not appear in the least bit friendly, showed nothing that would suggest friendship or sisterhood.

June stubbed out the cigarette and started toward the stairs.

Startled, Germaine shut the briefcase and got to her feet. "Are we done?"

"Well, yes," June replied as if this were obvious. "When you bumped into April in the bookstore, you blew it. She's seen you, Germaine."

"Blunders can work out, as this one did. There's more to be done, questions to answer. How is Mr. Friar involved? Does he own the shop? Who lives in the house above the bookstore? What's his connection to April? Was she simply using the store as a passage to another place, or did she meet someone there? You saw the photographs; this was the only time she stopped and looked around before proceeding."

June looked at her watch and shook her head. "Overall, you did fine. Don't act so *needy*."

June disappeared down the stairs.

The dismissal was rude, insensitive, and unfortunately, accurate. Germaine grabbed her briefcase. At that moment she remembered the thirty-five-millimeter negatives tucked in thin plastic sheaths, which June had forgotten to ask for. Germaine

prided herself on her honesty, even if at times she was not com-
pletely forthcoming. Still, she hesitated. Then with a shrug she
reopened the briefcase, set a thick manila envelope on the chair,
and pulled out the invoice itemizing her expenses.

June waited at the bottom of the stairs holding Germaine's
gabardine raincoat. While descending, Germaine said, "Maybe I
made a mistake but in case you've forgotten, I'm the one who sug-
gested you hire a professional P.I." Germaine took her coat. "You
forgot to ask for the negatives."

"Where are they?"

"Beside the hearth."

Germaine handed over the invoice. While studying the paper,
June moved into the dining room. Germaine followed, putting on
her coat, and watched June toss the sheet with her fees and ex-
penses into the fire.

"I'll have the money messengered to you."

"Can't you write me a check?"

"This business is strictly confidential. No records. Don't worry,
you'll get your money."

Germaine was stung by the hard tone and again felt de-
meaned.

"So, this is it?"

"For the time being."

They moved back to the door where June surprised Germaine
by giving her a hug. "Don't look so forlorn. I really appreciate
what you've done."

Disquieted by this unnatural display of affection, Germaine
pulled away and picked up her briefcase. "I get the feeling you'd
rather I didn't stay for the sleep-over."

"By all means, stay if you like."

"I'd best get home." She reached for the doorknob.

"Just one more thing," June said lightly.

Germaine turned her head. "I hope you were kidding when
you mentioned attending the Feng Shui lecture at the Women's

Place. That's simply unacceptable. We have to maintain our ano-
nymity."

"Right." She paused and tried to smile. "Say good night to the
others for me. Guess I'll see you next month."

Germaine dashed out into the rain, seeming to land in every
puddle before reaching her car. Sliding onto the driver's seat she
let out a monumental sigh. Through the streaky windshield she
saw June covering the last few feet to the kitchen door.

While rain pounded the convertible top, she reached for the
glove box and pulled out the cigarettes. After buckling herself in
she sat for a moment staring out the windshield at the back of the
big house.

She had just stuck a cigarette between her lips and was about
to light it when she noticed June peering out the kitchen window.
A chill slid down her spine and she jumped involuntarily, just as
she had upon arrival.

"Christ," she muttered. Tossing the cigarette on the floor, she
switched on the engine, the urge to leave far stronger than the
urge for nicotine.

Chapter Four

ON THE following Friday at 5:30 P.M., Salome Waterhouse stepped out of a taxi in front of the Willard Hotel on Pennsylvania Avenue. The driver opened the trunk and helped retrieve a tackle box, a dollhouse, a folded red silk fan that, when open, would span four feet, and a large Chico's shopping bag. She paid the fare from Georgetown and included a substantial tip. Standing amid her strange assortment of parcels, she looked out on the stream of vehicles, hoping her ride would arrive quickly. Dressed in the long black cassock-like robe, she resembled some sort of priest.

A bellman approached, eyeing her and the items arrayed at her feet. She told him she wasn't staying at the hotel and expected to be picked up momentarily. When he strode off, she resumed her anxious watch on the traffic.

Located just two blocks east of the White House, the Willard had recently undergone a massive renovation to both modernize the facilities and restore the interior to its original Beaux Arts opulence. She looked forward to one day experiencing the venerable hotel's rebirth but at the moment it was simply a point of departure.

Earlier, while Salome prepped for the evening ahead in her Georgetown town house, Cookie Freeman had called with news of a change in plans. Because of an emergency in her restaurant's kitchen, she would not be taking Salome to the Women's Place. Instead, her daughter, Chimene, would give Salome a lift.

"I hope it's not too much trouble," Cookie had said breathlessly, "but would you meet her outside the Willard at five-thirty? That's when they're taking a dinner break. She's studying with a friend on F Street, just around the corner from the hotel. Apparently, she's got some big exam tomorrow. I'm not sure if she plans to stay for the presentation or if she'll return at nine to take you home."

"Will there be a problem with me arriving early?"

"Already checked. No problem."

Salome had no choice in the matter. She wouldn't be allowed at the halfway house without an escort. Chimene, who had painted the exterior of the home the previous summer, was one of a handful of people approved to visit.

She'd been looking forward to seeing Cookie since last Saturday when she had called Salome's California cottage to make arrangements for the presentation. Cookie always filled her in on what had been happening in the D.C. area while she'd been wintering in California. Her flight had arrived Wednesday evening, not enough time for her to visit friends and settle in yet.

A sleek black Jaguar slid to a stop in front of her.

Salome took a quick step back. Bad experiences with certain people who drove Jaguars had created an aversion to the otherwise splendid automobile. And she hardly expected the twenty-year-old Chimene Freeman to be driving such an expensive car.

The tinted passenger window began to lower.

Salome's heart quickened and she took another step back and to the side. Another thought occurred to her. Maybe the driver had mistaken her for a hooker. She nearly laughed at the absurdity and settled on a tourist wanting directions.

The trunk popped open.

"Hurry up, Salome. Toss your stuff in the trunk. We need to get going!"

More stung by the harsh greeting than surprised, Salome struggled to lift the dollhouse. Bending her knees to absorb the weight, she had to shuffle so as to avoid stepping on the hem of

the long skirt. The other items were easier to manage and after a few moments, she closed the trunk and moved to the passenger door.

Chimene was one of those churlish people who give affection with the same enthusiasm shown by Scrooge when he parted with a penny; not a pleasant person to be around. Deciding to use a little Feng Shui to dispel her own negative feelings, Salome raised her arms and flicked the two middle fingers of each hand across her thumbs nine times, imagining chunks of bad energy shooting off into the ether.

"What are you doing out there? Get in the car!" Chimene bellowed.

Feeling better, Salome slid onto the gray leather seat and pulled the door closed. Immediately, her head jerked back onto the headrest as Chimene shot into traffic, to Salome's way of thinking, catching up with the energy Salome had just spun off.

Chimene increased the volume on a CD she'd been playing, a clue she did not welcome conversation. Salome fumbled to fasten her seat belt, swaying from side to side, while Chimene maneuvered the automobile through heavy traffic. The car's jerky movements were in counterpoint to the relaxed sounds of Bobby Hutcherson on vibraphone—not the heavy metal Chimene usually favored. She wondered which boyfriend had loaned her the car. Taking the silence and Chimene's preoccupation with driving as an opportunity to study her companion, Salome thought of more questions.

Silver lamé coated Chimene's lithe body to midthigh, leaving the right shoulder and arm bare. A single strand of crystals dangled from her right earlobe down to a tiny rose tattoo on the velvety brown skin just below her collarbone. Were coffee, cookies, and Feng Shui with a group of women challenged by substance abuse on Chimene's agenda for the evening? Salome didn't think so. Nor did she appear dressed for hitting the books.

Had she just come from a photo shoot? But as far as Salome knew, Chimene's modeling days had ended last spring near the

conclusion of her freshman year at Georgetown University, her father's alma mater. Thirty thousand dollars in credit card debt had gotten her in serious trouble. Partly to blame were the high maintenance costs associated with launching what she hoped would be a lucrative modeling career.

The youngest of Cookie and Judah Freeman's three children, Chimene was extremely bright and high-strung, and as she got older, evidence of having been spoiled rotten by a besotted father appeared as bad behavior and a rude, condescending attitude toward anyone who didn't flatter, admire, or agree with her. But since it was her nature to find a positive side to everyone, Salome chose to admire Chimene's driving ability.

Not waiting for her to reach her teens, Judah taught her to drive when she was all of seven and unable to see over the dashboard unless perched on his lap. Early on, she learned to judge distance and speed. Later, he taught her the techniques of high-speed chases and how to execute three-point turns, skills he'd perfected over the years with the Metropolitan Police Department. Chimene's knowledge of the city streets reflected Judah's own. Threading through traffic in northwest Washington and finding uncongested streets into Maryland, she finally merged onto the Beltway heading north.

Reaching over to the console, Chimene lowered the volume.

"Okay, this is the deal. After I drop you off, I'm going to an audition for a part in a movie being filmed here in D.C."

"Oh!"

"But you can't tell Mom and Dad. They'd kill me."

"Your mother thinks you'll either be at the Women's Place or studying."

"I was studying!" Chimene snapped. "For the audition."

"Use a little foresight here, Chimene. Being in a movie is not exactly surreptitious activity. What happens when they see you on the big screen?"

Chimene gave her a thoughtful look. "So you think I'll get the part?"

"I think your mother will be hurt if you do and don't tell her about it. After last year—"

"That's just it! How can I pay back Dad if I can't make any money? Sure, they don't want me involved in this sort of thing but that's now. By the time the film's released, everything will have changed."

Salome took a deep breath, considering what would happen to her friendship with Cookie and Judah when they discovered their daughter's deception, and that she'd known about it.

"You're putting me in a bad position."

Creating a frosty silence, Chimene stared straight ahead, the bumper-to-bumper traffic not improving her mood.

"You're sure this audition is legitimate?"

"My agent would never steer me wrong."

"I thought you left the agency."

"Well, I didn't! I know where you're going with this—the audition is in my agent's office, not some sleazy motel. Okay?"

"You're not exactly dressed for the role of Mary Poppins." Salome sighed. "Look, my friendship with your parents may mean diddly to you but it's important to me. I can't be a party to your deception."

Before Chimene could react by pushing a button that might eject her from her comfortable seat, Salome quickly offered a solution. "However, if you're my client, I cannot disclose anything you tell me."

"Your client?"

"Sure. I'll Feng Shui the car."

Chimene's almond-shaped black eyes strayed momentarily from the road, regarding her passenger with incredulity. "You're joking! You can Feng Shui a *car*?"

"I can Feng Shui anything."

After a momentary hesitation, Chimene said, "Okay, how much will it cost me?"

"Your time to and from the Women's Place."

"How long will it take?"

"Not long if you pay attention and I don't have to repeat myself. So what's the part you're auditioning for?"

Chimene ignored the question. "With the money I can make, I could pay for at least two more years at Georgetown—or whatever." She went on to say she had maintained a perfect grade average since enrolling at George Mason University in Fairfax, Virginia, last summer. "I won't have any problem getting back in."

"The part?"

Chimene glanced briefly at Salome, then back to the congested traffic on the highway. "Finally! We're almost to the exit."

She switched on the right turn indicator and began changing lanes, edging in front of other cars, incurring the wrath of those in her way if the honking horns were any indication. Chimene was an opportunist, would do whatever she had to do to get ahead; those behind her be damned.

"Once we're off the highway, the Home won't be that far. You'd better start my lesson."

"The part?" Salome persisted.

"A high class call girl."

"Oh, that'll please Cookie and Jude."

"Well, you're not going to tell them!" Salome saw murder in the black eyes when they jerked her way momentarily.

Finally Chimene made it to the exit ramp. In moments they were on a two-lane road heading west.

"Who owns the car?"

"A friend."

"In what business?"

"Shouldn't this be about me?" Chimene said. "This is what I thought: I arrive at the audition totally in character from the get-go. High-class car, expensive clothes, the walk, the talk."

"Okay. Do you remember anything about the Feng Shui presentation I gave at your mother's restaurant last year?" A Ghanaian linguist staff for which Chimene had been responsible to

present at the subsequent auction had gone missing while in her care, which made the evening quite memorable.

"Like what?"

"The Bagua?"

"Sort of."

"The Bagua is the template I use to determine the location of life situations."

"Yes, yes. I remember, more or less." They sped through a rural Maryland farming community.

"Imagine a grid divided into nine equal squares in three rows of three. Each square is called a gua."

"Got it."

"Taking the bottom three first, as you face the grid, on your right is the helpful people and travel gua. In the center is career. The knowledge and spirituality gua is located on the left."

"Okay."

"Moving to the middle three, on the left is family and health. The square in the middle represents the overall harmony of the entire grid. Then on the right you have children and creativity."

"Middle of the grid," Chimene intoned, "family and health, harmony, then children and creativity. Gotcha."

"At the top, on the left is the wealth sector. At center is fame and reputation, followed on the right by relationships."

Again, Chimene repeated what Salome had told her.

"Now, facing the Jaguar, superimpose the Bagua."

"The Jaguar hood ornament in the career position," Chimene said.

"Exactly. Where is fame and reputation?"

"The back center."

"Wealth?"

"Left of fame."

"Overall harmony?"

"Absolute center."

"Certain colors and elements—earth, fire, water, metal, and wood enhance the corresponding guas." Salome took a deep

breath. "Well, there's no time for those details." She shook her head. "I really can't believe I'm condensing three thousand years of Feng Shui knowledge in minutes."

"Quick and dirty, as they say in the movie business."

That hardly salved Salome's sensibilities. Still, if she could turn on Chimene to Feng Shui fundamentals, maybe the perfunctory lesson would be worth it.

"Now tell me your needs, what you want."

"To get the part, to make some good money." She paused, then added, "And might as well add fame to the equation."

"Instead of fame, I suggest stimulation of the helpful people gua. On the Bagua, wealth is at a diagonal from helpful people. There's a good reason for this: we don't achieve wealth without others. In your case, helpful people refers to the person or persons who make the decision to cast you. Not only that, but moviegoers."

Just a moment later, Chimene pulled off onto an unmarked gravel drive hugged by trees, shrubs, and wild vines. Up ahead loomed a rambling, two-story farmhouse with a long porch extending across the front. Chimene stopped the car behind a cream-colored van and released the top of the trunk, then reached into the backseat and grabbed an ordinary trench coat. She buttoned it to the neck and exchanged her sexy sling-backs for a pair of Dr. Scholl's sandals.

"So, what now?"

"Polish the hood ornament and while doing so, clear your mind of everything except the audition. Imagine succeeding. While you do that, I'll take care of the wealth and helpful people guas."

"Go for it!"

Salome felt that Chimene's attitude toward her had moved in a more positive direction. As she started to exit the car, Salome said, "You know, if you ever run out of job opportunities, you could work for a Metro cab company."

Chimene laughed sardonically. "Then I'd better concentrate

extra hard on the career gua." She plucked a black silk scarf from her handbag and held it up. "How about I use this?"

"Perfect. Black is the color associated with the career gua. Remember, envision success; envision *details*."

Chimene polished the forward-thrusting Jaguar emblem, her expression serious and intensely focused.

Salome moved to the trunk and opened her tackle box. From a wide selection of faceted crystals, she chose one about the size of a cherry and tinted purple. It hung from a premeasured nine-inch length of red cord. To prevent it from rolling around, she taped the cord to the side of the wheel well to her right, the Jaguar's wealth sector as determined from the front of the car. To begin the ritual to focus intentions, she placed her hands in the proper mudra in front of her chest, palms up, left over right, thumbs barely touching. She took a breath and cleared her mind. Then she chanted, *"Om ma ni pad me hum..."* nine times, expressed intent—that "Chimene receive abundance from the movie role"— while holding a picture in her mind of Chimene looking radiantly happy.

Concluding the ritual, she rooted around in the tackle box searching out just the right enhancement for the helpful people/ travel gua. Gray was the requisite color and metal the element associated with that gua. A wind chime with metal prongs would be an excellent enhancement, having the corresponding element and the energy-raising benefits of sound. But those she had brought were too big, with the exception of the tiny wind chime she'd made for the dollhouse. Then she spotted a metal Kwan Yin goddess figure about two inches tall, which represented a strong mentor and guide.

She also picked up a two-by-two-inch magnet featuring the Chinese character for "Longevity," a popular Feng Shui enhancement for vehicles.

She hurried around to the driver's side just as Chimene moved off toward the house. Using double-sided tape, she affixed the small Kwan Yin on the dashboard at the left of the steering wheel

(the position more accurately on the cusp of helpful people/travel and children/creativity), then performed the ritual as she had done at the trunk, only this time expressing and envisioning Chimene being offered a contract.

Finally, she placed the Longevity calligraphy on the dashboard near Kwan Yin, to symbolize safe, accident-free travel. She exited the Jaguar at the same time Chimene and a robust black woman, her hair a profusion of honey-colored corkscrew curls, descended the porch steps.

Meeting at the back of the car, Chimene made the introductions, her dramatically made-up face somewhat incongruous given the ordinary trench coat and sandals. "This is Louvee Novack. Louvee, Salome Waterhouse."

Salome and Louvee emptied the trunk and Chimene slid behind the wheel and started the engine. Salome closed the trunk and moved over to the driver's window. She pointed out the Kwan Yin figure and Longevity magnet and told Chimene about the crystal in the wheel well.

"Cool."

"You'd best remove them before you return the car. And thanks for the ride. See you at nine."

"Wait! The audition might run late. But don't worry; Louvee'll give you a ride to the nearest Metro station. From there you can catch a cab."

Straightening, Salome realized that was what Chimene intended all along. Chimene turned the car around and sped off, spitting gravel in her wake.

Salome's shoulders slumped. When it came to sucking energy from others, Chimene was lethal as quicksand.

Salome rejoined Louvee, glad now of being early so she could rest, maybe enjoy a cup of tea, before the presentation.

However, like the evening thus far, that plan was about to change.

Louvee lifted the dollhouse. "Didn't Chimene tell you? We don't have children here."

"Actually, I use the dollhouse for demonstrations: to move furniture around and show good and bad positions of furnishings."

"What a great idea. I'm really looking forward to your presentation. And Salome, I'm glad you're early. We've had something of a disaster and maybe you can help."

Chapter Five

"*THE MORE* you know about your environment, the better you will understand your place in it," Salome began at 7:30 sharp. The nine young women gathered on the worn sofas and chairs couldn't have been more different from the prim, well-dressed groups she usually spoke to. But she had prepared, knowing that to reach these women, she had to address their unique needs.

"And as you begin to understand Feng Shui you will begin to understand your place in the world—and feel better about yourself, more comfortable in your own skin, as it were."

After setting up for the presentation, she and Louvee had scrubbed the kitchen, Louvee providing a pair of old dungarees and a sweatshirt that fit Salome's slight frame. Though Louvee apologized for enlisting her help, Salome regarded the situation as an opportunity.

Salome explained that basic to Feng Shui was cleaning and the clearing of clutter. The kitchen, she pointed out, is integral to the overall prosperity of the residents.

In the case of the Women's Place, the kitchen, the stove especially, indicated financial distress. Only two of the electric burners on the four-burner stove were working. The round trays beneath them were crusted with charred food particles. No one had bothered to scour the built-up grease globules from the surface and the oven was a black hole. To make matters worse, after an argument with her boyfriend on the telephone, the woman in charge of cooking that evening's meal had taken out her anger on the

kitchen, hurling open bottles of salad dressing against the walls along with the salad itself and a pot of canned spaghetti. She'd then called her mother, who picked her up.

"We'll never see her again," Louvee had lamented. "And she's one of those deeply disturbed women who need a place like this. For one thing, the shelter lets these women know they're not alone in the world. They can interact with others who've gone through the same things. And of course, she totally disrupted the schedule. The schedule keeps us sane and focused."

At the moment, "bored and hostile" more adequately described the general attitude. They looked drab and pale; even the young African-American woman had a gray cast to her brown skin. Still, Salome was determined to reach them.

"Feng Shui is commonly known in the west as the art of placement, which refers to placing furniture and decorative items in harmonious positions. The object is to create an environment of balance and harmony. The primary goal of Feng Shui is to attract healthy, lively energy into our homes. We call this energy *ch'i*."

She picked up a stack of papers on which were printed colorful Baguas but as she was about to hand them out, attention was diverted when an older woman entered the room. Louvee shot up from her chair.

"Ladies, uh, this is Germaine, a friend interested in learning about Feng Shui. Please continue, Salome."

Louvee hustled the new arrival to a seat in the back of the room.

Salome resumed, giving each woman, including Louvee and Germaine, a copy of the Bagua. Salome stepped over to the retractable easel upon which perched the brand new, laminated, octagonal Bagua, each gua vibrant with its respective color, sensing that they would respond positively to color, having so little around them. Recalling a comment Louvee had made while they cleaned the kitchen, she had an idea of how to capture the interest of her audience.

She looked at each woman, trying to make eye contact. "I have

this funny feeling that you'd all much rather be watching 'Wheel of Fortune.'"

Her audience perked up. There were some smiles and a few snickers.

Putting her hand on the Bagua, she said, "Well, this is a real wheel of fortune, what we call a Bagua." Now having their attention, she began by pointing to the bottom center. "This is career, the associate color, as you see, black. Notice the bright blue of knowledge and spirituality here on the bottom left and above that green, the color of family and health. Up here on the top left is rich purple for wealth, and beside it, bright red for fame and reputation. Love and relationships here on the top right has pink as its color. And here, in the middle right is white for creativity and children. This gray part is helpful people and travel. And finally, here in the center we find yellow, this section referring to overall balance and harmony."

She stood to the side and added, "Like I said, this is a real wheel of fortune; this one can change your life. And I'm here to show you how to do just that.

"Let's begin by taking a look at each of your rooms. Bring your Baguas."

Salome opened the door to the first bedroom. Directly ahead was a single bed piled high with what appeared to be dirty laundry oddly fashioned into an arc. Assorted pairs of shoes were scattered around the bed.

At a diagonal from the entrance and facing into the room was a small student desk, the surface polished and sporting a single reading lamp. Behind the desk chair hung a poster of a lush tropical landscape with a waterfall plunging through the center. HA-WAII was printed at the bottom.

A small bookshelf separated the desk and bed, the shelves and floor in front of it crammed and overflowing with tattered paperbacks. Glancing at the titles, Salome could see that most were romances. A ten-gallon aquarium, home to flourishing plants and

numerous red and blue neon Tetras, perched on a stand to the left of the door.

After about five minutes, Salome began her assessment as the women crowded just inside and around the door.

"I would say the person who lives in this room has trouble sleeping. She most likely has a reputation as a heartbreaker; probably dumps a guy before he gets the chance to know her or she to know him. She may have a difficult relationship with her mother.

"On the positive side, I'd say she doesn't have serious money problems. She always has it or manages to get money when she needs it. Once she gets her act together she can be a successful career woman."

Salome heard a sharp intake of breath. Other than that, no one made a sound. Had they been stunned to silence? Clearly she'd gotten something right. A woman with silky blond hair that fell to her waist stepped forward and introduced herself as Jane. Salome recognized her as one of the most bored at the start of the presentation.

"Uh, how did you know all that?" she asked, flicking her hair to the side.

"Why don't you follow along, using your copy of the Bagua."

Salome pointed out the relationships gua. "Your bed is here and the mess on top suggests problems in love. The way you have your clothes piled up, it appears that the clutter is permanent, suggesting a deeper problem, one involving your mother. You see, the relationships gua also represents the mother."

Jane's face reddened. "I can never please her! She hates the way I dress, the way I look—all my choices." She went to the bed and sat on the end, her expression defiant. "But it feels comfortable to me like it is, like a nest."

"Well, consider the location of the bed, directly in front of the door. In Feng Shui, this is known as the funeral position, as it represents a body being taken through the door feet first. Also, the energy entering the room hits the bed and disturbs sleep. By pushing the bed up against the wall you are not providing room

for some else to share; symbolically this suggests that you are not serious about committing yourself to a relationship.

"On the other hand, you are very much interested in love, as your choice of reading material announces loud and clear. Still, you show little respect for the books, jamming them into the shelf and simply tossing others in a jumble on the floor.

"So, right beside each other, in fame and reputation and relationships, we can see how conflicted you are."

Salome moved across the small room to the bookshelf and pointed out half a dozen books opened with pages flat on the surface and spines broken. She spotted a couple of snapshots of Jane with smiling young men, that were collecting dust.

Showing interest now, Jane asked for advice.

"If you honestly like these guys enough to keep their images available, frame the photos. Put the bookshelf where the bed is and move the bed here. Find a curtain or a piece of material you like, hang it between the bed and the desk. I understand that you don't have a lot of room to work. But, separating the bed from the desk is important and a curtain will do the trick. And hang your clothes in the closet and tidy the bookshelf. Get rid of books you've read to make room for new ones. Make this relationship area a sort of sacred space. Add flowers and photos of people you really love."

"Let's move on, okay?" Louvee said. "Otherwise Salome will be here all night."

They moved down the hall to the next room.

Louvee opened the door, which was in the helpful people/ travel gua like Jane's room, and Salome stepped inside. It didn't take Feng Shui to know who lived in this space. She took the opportunity to say, "Our homes reflect who we are," then turned to the slight young woman with short, dyed black hair and multiple body piercings. She wore a Xena, Warrior Princess T-shirt, black jeans, and cheap black boots, Doc Martens knock-offs.

"What's your name?"

"Casey."

"Casey, is this your room?"

Everyone laughed.

The walls were covered with dozens of black-and-white sketches of sword-wielding muscular women interspersed with some beautifully rendered dragons. Though the work was excellent, none had any color. The furnishings were spare: to the left of the door a laundry basket, then a single mattress on the floor, and a cinder block with a small lamp that acted like a night-stand. Sketchbooks and pencils were within easy reach of the bed. There was just one other item: on the wall opposite the door was a display of shot glasses from cities along Route 66.

"Given your reason for being here, Casey, I suggest that you retire that collection."

There was some sporadic laughter.

"Look where you have it."

Casey consulted her Bagua. "Oh, wow!" she exclaimed. "It's in the relationships gua!"

"If you're not already earning a living from it, I'd say you could put a portfolio together and find work as an illustrator of graphic books. And may I make a suggestion?"

"Sure," Casey said, eyes bright and eager.

"Add some color to the room."

"I don't plan on staying."

"That's good." Salome moved over to an elaborate pen-and-ink dragon about three feet long in the center of the wall left of the door, hovering above the bed. "Dragons are extremely auspicious in Feng Shui. They convey great power. Especially red dragons, which would be an excellent addition across the room in the fame gua."

Louvee said, "You know, Casey, I've got a box of colored pens in my office. You're welcome to them."

Casey looked up at the dragon, then at Salome. "It's in the career gua, right? Since the door opens into the helpful people and travel sector."

"Right."

Salome picked a pen off the floor and handed it to Casey. "Why don't you sign it?"

Casey looked startled. "Wow! I didn't even think about that." As she scribbled her name in the right-hand corner, the other women applauded.

By the time Salome had Feng Shuied each woman's private space, the atmosphere crackled with excitement. The ch'i had definitely risen.

Back in the living room, Salome opened the tackle box and one by one, showed them Feng Shui enhancements, items used to raise ch'i. First she slipped a red cord over her finger, letting the clear twenty-millimeter, faceted crystal it held spin around. She moved to the nearest lamp. The facets caught the light and filled the room with vibrant dashes of the color spectrum.

"The red cord itself further enlivens the crystal's energy. We use red cord or ribbon cut in nine-inch increments. So, say you have a high ceiling, you'd want the cord to be at least eighteen, maybe thirty-six inches in length; the reason being that nine is the magic number in Feng Shui. Any number multiplied by nine will be reduced to nine. Nine times four equals thirty-six. Add three and six and you get nine."

Salome handed the crystal to Casey, who was sitting by the lamp. "Pass that around, if you would."

Salome pulled a wind chime from the box. "It's common practice to use wind chimes inside the house because their sound lifts the ch'i. Remember that Feng Shui works on several levels. There's the actual and the symbolic. We hit the wind chime and it makes an inviting noise. Even when the air is hardly moving around it, it represents sound and in doing so still functions to raise the ch'i."

She then gave the wind chime to another woman to pass around.

From the Chico's bag she now produced a potted live jade plant. "Because the leaves are rounded and more like coins than blades, jade plants are popular enhancements in the wealth/pros-

perity sector. In fact, it is much better to use plants with rounded leaves inside the house. Thin blade-like leaves can create cutting ch'i, which I mentioned earlier in regard to the sharp edge of the wall jutting into the TV room. Sharp pointed objects relate to fire. Rounded objects relate to water."

Salome gave the plant to Kyna, a reticent young woman of African-American and Vietnamese heritage. Kyna's room had been stark in the extreme, with only a bed and a cardboard box for her meager supply of jeans and T-shirts. "Why don't you keep the jade plant. A good place for it would be in the wealth sector of your room."

Kyna smiled a thank you.

"Flowers and plants always perk up the energy wherever they are placed. A bouquet of flowers provides a feeling of welcome in any room of the house."

From the bag Salome now withdrew a stack of felt squares in every color. "These are very inexpensive and you can get them in most craft supply stores. Let's say you have a gray couch in the Fame and Reputation gua, which just won't fit anywhere else in the room. And you don't have the money to buy a red slipcover— or maybe you just don't feel comfortable with a lot of red. You could put this red felt square under the seat cushions or even affix it to the back of the couch. The important thing is, you will know the red color is there enhancing your fame and reputation. That awareness will work to your benefit, supporting whatever you do to bring about a positive change to the way others regard you. I'll leave these on the table and anyone who wants one may help themselves.

"Mirrors are also popular in Feng Shui." Salome pulled out a small object wrapped in purple tissue. She held up a round mirror three inches in diameter. "I recommend these small mirrors be adhered to the outside of bathroom doors. This helps contain the energy within. Bathrooms have special problems. Water is the element associated with money so flushing the toilet symbolizes a drain on finances. The way to minimize the effect is to keep the

lid on the toilet down when you flush and when the toilet is not in use. And keep the bathroom door closed."

Salome went on to suggest lights, fountains, large stones (to stabilize the energy), statuary, whirligigs, and flags as useful tools to stimulate the flow of energy. "Take time to become familiar with your belongings."

Someone said, "That won't take Kyna any time at all."

Everyone laughed, including Kyna.

"Discover what you really like and get rid of anything that doesn't suit you. Declutter your lives. Maybe some item was important in the past but no longer feels right—I'm thinking of those shot glasses, Casey. You're different now and they are just holding you back."

Chimene, true to form, did not arrive at nine, but unaware of the time, Salome did not notice, nor did anyone else, not even Louvee.

Toward the close of the presentation, everyone trooped outside to the porch. Louvee stood on a ladder on the front porch and Salome handed up an octagonal Bagua mirror. Louvee hung it above the front door.

"This Bagua mirror will provide protection for the house by deflecting negative energy."

As Louvee climbed down the ladder, Salome said, "Now, there's one more thing I'd like for us to do, as a group."

Salome passed around a brown paper bag containing rice and asked each of them to grab a handful. "Some of you may think this is a little weird but kindly humor me. It's what I call chasing out the demons."

With Louvee in the lead holding the flashlight, they sprinkled rice as they walked in single file all the way around the house. Behind Louvee, Salome softly chanted a blessing.

The final task complete, they returned to the living room. "You see, the rice attracts any evil spirits out of the house. Just consider it an old custom."

Louvee moved beside Salome. "On behalf of all of us, I'd like

to thank Salome for visiting the home and sharing her unique wisdom."

The women applauded. Casey added a shrill whistle, and then asked, "Hey, is that good Feng Shui?"

"Of course," Salome said. "Especially coming from you."

Salome smiled and put her hands together in the prayer position at her chest. She bowed slightly and said, "*Namaste.* The light in me salutes the light in you."

The evening now concluded, the women began to disperse while Salome packed her Feng Shui supplies.

"Oh dear," Louvee said looking at her watch. "It's past ten. And Chimene's not here."

The positive energy generated over the course of the evening had given Salome such a good feeling that not even Chimene's absence and the lack of a ride home lowered her spirits.

"If it's not against the rules, may I call a cab?"

"That'll be expensive."

"It's all right."

"No need for that," Germaine said stepping forward. "I'd be delighted to give you a ride."

"Salome, this is Germaine Brilliante," Louvee said. "She's one of our fund-raisers. Technically, she's not supposed to be here but, well, I made an exception."

"You don't tell, I won't tell," Germaine said. "And Georgetown's on my way."

Salome gave her a puzzled look. "You know where I live?"

"How about, I explain in the car."

Chapter Six

AFTER TELLING Salome about her role in vetting her for the presentation at the Women's Place, Germaine segued into something akin to opening a vein. All the distress she'd felt after last week's SOW meeting and June McGann's treatment of her poured out in a rush. It helped that Salome was a good listener, a skill Germaine, as a former journalist, valued highly.

"Someone at the meeting suggested that I write a book about the celebrities I've covered over the years. Even said it would be a bestseller," Germaine continued, her voice getting higher. "Well, I get home and dammit if it doesn't pop into my head to write a book about the McGann family!"

Germaine looked over at Salome as if seeking approval.

"Make certain your intentions are good," Salome cautioned, now feeling uneasy as they passed through Chevy Chase and into the District. "If you write this book about the McGanns simply to take revenge on June, the effort may backfire on you."

She glanced over at Germaine. "Why we do something exposes our character as much, if not more, than what we do."

Another skilled driver, Salome mused in the silence that followed. Still, she knew Germaine wasn't concentrating only on the variables involved in reaching their destination. Nor was Salome just reflecting on Germaine's expertise behind the wheel. Fear had been tweaked with the mention of April McGann.

Finally, Germaine blurted, "I talked to an agent of a friend this week. She's *really* keen on the book and wants a proposal...

yesterday. She wants to do an auction." Germaine took her eyes off the road momentarily to look at Salome. "You probably know what that means, having been married to a writer."

"Oh yes." A lot of work for an agent, who had to generate abundant enthusiasm among a variety of editors for an auction to succeed in attracting higher and higher bids.

"I'm nearly broke, having lived on most of what I've saved— and some investments—since my health started interfering with work. As far as the book is concerned, I have great contacts and no qualms about ferreting through the dirty laundry of the rich and famous, friends or not. The problem, of course, is money to get by on. I figure it will take a month to come up with a solid book proposal. In the meantime I have to live.

"After seeing you in action tonight, I just know you can help me. I don't know what you charge for a consultation but maybe we can work out a trade."

"We can determine a fee later." Salome had perked up when Germaine mentioned following April McGann for two weeks. McGann was the former fiancée of Salome's nemesis, Duncan Mah. With or without a fee, Salome would certainly trade her services for information that might lead to tracking down the elusive and menacing Mr. Mah. At the moment, though, she did not want to divulge her own interest.

Since the previous spring when Mah became a neighbor, moving into the manor house at the end of Malabar Close—under false pretenses—trouble, too, had settled in. Bad enough that he was an imposter, a Snakehead in the business of illegal Chinese immigration, but he had also destroyed the only source of good ch'i by pouring asphalt over the rose garden. All the vibrant energy that had fed the Close for decades, Mah paved so his Jaguar could be displayed in front of the house.

"I might be able to help you out with work, I mean, if you're interested in private investigation, since you said that's what you've been doing. A good friend of mine has his own firm. He's a retired Metropolitan homicide detective, a Georgetown grad who

got sidetracked from his own plans to be a writer years ago. He doesn't have a full-time licensed staff, not yet anyway. The people he uses come from all walks and do grunt work—stakeouts, looking through county and municipal records, the non-sexy stuff. You having been a journalist, I'm sure he'd appreciate your FORs. By that I mean, field operative reports. I'd be glad to introduce you—"

Salome stopped in mid-sentence upon seeing the swirling colored lights of emergency service vehicles and the fire truck blocking the entrance to Malabar Close.

"Oh dear," Germaine whispered. She pulled up to the curb just short of the street and behind a small crowd of onlookers. Salome grabbed her handbag, and with a worried look said, "Do you mind waiting while I find out what's going on?"

"Wait? I'll come with you."

But Salome was already out of the car, pushing her way through the crowd. From the strong smell of beer and the youth of the onlookers, she figured they were mostly Georgetown students come from Friday night revels at the local bars.

A policeman barred her entry. She told him she was a resident. When he demanded ID, she plunged a shaky hand into her purse and brought out her wallet. She looked around him, her eyes already beginning to tear from the smoke.

The policeman turned and shouted, "Hey Freeman! She's here."

To Salome's further shock, Judah Freeman trotted toward her clutching a wadded handkerchief. He wore running shoes, jeans, and a short-sleeved light blue shirt patchy with perspiration. Rivulets ran from his hairline down the black skin of his craggy face, the sweat glistening with the reflected multicolored lights. She heard loud, hollow chatter from police and fire radios and grimaced at the acrid smell. For a moment she felt as if she had stumbled upon some sinister amusement park.

"What's going on?"

He grabbed her arm and steered her toward the end of the cul-de-sac, across the narrow street from her own house. He said

nothing until they were standing in front of the manor house that marked the turnaround for the tiny block.

"I'd hug you but I stink."

"The stench isn't coming from you," she said. This being the first time she'd seen him in months, Salome gave him a hug. When she pulled away, she managed a smile. "On second thought, maybe a little bit is."

"Welcome home," Judah said, his face set like black marble.

Salome's Australian neighbor and friend Fiona Cockburn, a small video camera in hand, had no qualms about her own scent and dashed up, hugging Salome tightly. Over the top of Fiona's cap of curly purple-dyed hair, Salome stared at the scene beyond the black hole that had been her front window. Halogen lights illuminated the firefighters as they hacked at the living room wall. Through the open front door she saw them shuttling up and down the stairs. A couple of pieces of living room furniture smoldered on the sidewalk.

"Tell me what happened."

"Maybe you should have a brandy first," Fiona said, her dark eyes flashing quickly at Jude.

Ignoring the offer, Salome asked, "Has anyone been hurt?"

"Not as far as we know," Jude said.

"What are you doing here, Jude?"

"Uh, it's kind of a long story," he said.

"Start at the end then. What the hell happened?"

Fiona began. "Someone threw a Molotov cocktail through your living room window. Jude, uh, happened to be in the neighborhood and chased after them while I called nine-one-one."

"When?"

"About forty minutes ago."

"I should have been home by then," Salome said. "But the presentation went past nine." Suddenly she went rigid and surprised her companions by cursing. "The notes for my book were on the couch!"

"What book?"

Salome sighed. "The book I've been putting together on houses where murder has been committed, the similarities—oh dear! I'll be right back."

Salome ran to the top of the street where Germaine stood to one side of the slowly dispersing crowd.

"I'm sorry," Salome said. "There's been a fire at my house."

"If you need a place to stay, I've got plenty of room."

Salome thanked her but declined the offer. The two women exchanged home and cell phone numbers.

"Really, I *can* help you regain control," Salome promised.

Germaine looked skeptical. Cringing inwardly, Salome wondered if the fire had caused her to lose credibility. If she couldn't protect her own home, who could trust her?

"I do need my Feng Shui things."

"Of course!"

Together they unloaded the coupe.

"Please, don't let this turn you off to Feng Shui."

Just then Jude appeared.

"Germaine, this is the detective I told you about. Judah Freeman."

Judah and Germaine shook hands. Then Jude picked up the dollhouse and bag and carried them down to Fiona's town house next door to Salome's.

"I meant what I said about a place to stay," Germaine said, after a lingering gaze at Judah. She opened the door to the coupe. "Call at any hour. I'm a night owl."

"Thanks, Germaine. And certainly, thank you for the ride."

Salome picked up the tackle box and tucked the red silk and bamboo fan under her arm. The fan, with its painted gold dragon, was an excellent Feng Shui enhancement for any gua needing a sudden infusion of energy, especially fame/reputation since red was the corresponding color in that sector.

She turned toward her own house thinking the fame/reputation gua therein just might be in need of positive stimulation.

Then...

Chapter Seven

TEARS CAME to Salome's eyes when she saw Hokusai's famous woodblock print, *The Breaking Wave Off Kanagawa*, on the foyer floor covered in sooty water. The irony was not lost on her; the artist had been a keen observer of the movement of water. Popularly called "Great Wave," it was such a powerful piece, she'd sometimes thought it might be *too* powerful to display as the first thing seen when entering. And now the crashing wave had been crushed by the reality of the very element it represented. On looking at the staircase, though, she felt some relief. The crimson carpeting with the royal blue star pattern was a facsimile of that which covered the main staircase in the Virginia governor's mansion. She'd had it treated with fire retardant. Yes, the lower stairs were soaked but the carpeting could be cleaned and refitted.

To the painful sound of firemen hacking into walls both in the living room and the bedroom directly above, Salome and her escort, firefighter Nathan Barnes, examined the damage on the first floor, which seemed to have been contained to the living room and dining room only. Salome noticed the small, dull-looking teapot on the mantel. With a cry of delight that it hadn't been knocked to the floor, she put it in her purse. It was an heirloom brought to the United States by her Japanese grandparents. The teapot had survived two years of internment in Arizona during World War II, while her grandparents had not.

By the look of it, the remaining first-floor rooms had endured not much more than smoke damage. Still, it would be several hours before a full assessment could be determined.

Returning to the foyer, Nathan said in a low voice, "I can't let you upstairs yet but if you've got anything important up there— medications, jewelry— I'll get them for you."

Swallowing hard, she directed him to a drawer in the built-in cedar closet in her second-floor bedroom. "All the jewelry is in a white leather pouch. No meds."

Numbly, she watched him climb the stairs, her legs feeling heavy. Water began to seep into her shoes. Even so, she couldn't move, while the memory of the first time she'd stood in this very spot bubbled up from years past. She might have laughed had circumstances been different. Now she shivered.

It was the night her ex-husband introduced her to his beloved grandmother. She and Gabriel had come from The Tombs, Gabe's favorite bar, just around the corner, where they had both consumed too much beer. Mimi, as Gabe called her, had flounced down the stairs in a pink chiffon dress. Her cloud-colored hair, done in a bouffant, hovered about her tiny face like a massive thunderhead. Then she stopped midway down, eyes wide, mouth gaping.

"This is *Salome*?" she finally managed.

Mimi's comical expression, plus the quantity of beer consumed, released Salome's control of her bladder. Fortunately, rain streamed off their coats and no one seemed to notice the speed with which the puddle at Salome's feet grew.

And now here she stood in a far greater puddle, feeling she had come full circle. At such times she knew change was imminent.

Nathan descended the stairs, his flapping jacket and helmet eclipsing Mimi's image. A sob escaped her lips when she noticed the small suitcase he carried. Touched by his thoughtfulness, she fought to hold back the tears.

"When I saw the suitcase, I thought I'd toss in a few clothes with the jewelry."

Salome looked away, unable to speak.

Nathan walked her outside toward Fiona's town house. Half-

way there, she spied something on the ground. The wooden Bagua
with a round mirror in the center that she'd attached to the side of
the house last year lay on the tiny patch of newly sprouted grass.
She picked it up, then looked back at the town house. Another
Bagua mirror should have been hanging above the front door, but
was not there. She could not remember if both had been in place
when she arrived in Georgetown Wednesday night, a reminder
that she had neglected to perform Feng Shui protection rituals
upon her return. Self-directed anger joined the flurry of emotions.

"You'll be back in your house before you know it. Believe me,
it could have been worse, a lot worse," Barnes said and handed
over the suitcase.

Jude squeezed her arm, then walked back with Barnes.

"Oh luv," Fiona intoned and curled an arm around Salome's
waist.

Salome pulled off her sodden shoes and socks and padded into
Fiona's magazine-, book-, and paper-strewn living room. Had the
fire been here, there would have been enough fuel to create a
spectacular conflagration. Fiona dashed off to the kitchen, calling
over her shoulder, "Make a space anywhere. And don't be Feng
Shuiing while I'm gone."

Salome lifted the strap of her shoulder bag over her head and
extracted a tissue. She wiped her eyes, then took a few deep
breaths. Fiona needn't worry; Salome's career had just taken a di-
rect hit. At the moment, she was reluctant to give Feng Shui ad-
vice to anyone.

Fiona returned carrying a tray containing a bottle of Cour-
voisier, three snifters, a box of Ryvita crackers, a chunk of pâté, a
wedge of Stilton, plates and a knife. With her foot, she swept
books and papers off the coffee table to make room for the co-
mestibles and drink: Fiona Feng Shui at its best.

"What do you think Jude and the fireman are talking about?"
Salome said, stuffing the damp tissue in her pocket.

"Disaster, of course. Men create them. Men clean them up.
Men love them. Disaster: male *raison d'être*."

"I don't like being shuttled off and not included. Makes me feel useless."

"You're neither a firefighter nor a police officer. Let them deal with it, it's what they do. At the moment, you're a bit emotionally charged. Not to worry, you'll be back in control. Allow yourself time to get over the shock. I know you, having your house torched is on a par with having a friend—no, a blood relative—attacked."

Fiona poured and the two women clicked snifters. "Here's to retribution," Fiona said, her eyes sharp and black as onyx shards.

Salome remained silent. Hadn't she just cautioned Germaine against such action? For a moment, she felt the evening's negatives slap her face and changed the subject.

"I thought you were going to New York tonight. What changed your mind?" Earlier in the day, Salome had collected the houseplants that Fiona had kept in her small backyard greenhouse over the winter. Their meeting had been brief since Fiona was packing for a weekend trip to New York to research a new documentary.

"Circumstance." Fiona paused. "Happenstance. Enemy action. To paraphrase Ian Fleming."

Salome took a sip of brandy. "So. You and Jude?"

Fiona sniffed, then tossed back the remainder of her brandy. She gave Salome a guarded look before refilling her snifter.

"Love, lust has a glow all its own," Salome said. "And I have a sensitivity to light."

"Jesus."

"But what happened to Jamie?"

For several years, Fiona had cohabited with the young man in question, a student of anthropology at George Washington University. They had met at a seminar Fiona taught on documentary filmmaking.

"Ah," Fiona said, exhibiting another glow, this one less intense, more like forty watts instead of the hundred-plus Salome witnessed earlier.

"Jamie's off in the Outback. Searching for those he believes to

be my abo—excuse me—aboriginal roots. The lad never could ac-
cept that my antecedents were convicts."

At the moment of that declaration, Jude entered. He looked
from one woman to the other, then removed magazines and peri-
odicals from an overstuffed chair, which he then pulled up to the
coffee table. He tipped some brandy into a snifter, took a moment
to savor the aroma, then tossed the liquid down his throat. With
no change in his expression, he set the snifter on the table and
settled himself into the chair.

"Salome knows," Fiona remarked over the rim of her snifter.

Jude looked all business, his personal life off-limits. "A patrol
car will stay on site for the next twenty-four hours. Of course,
there's no question of your staying in the house. A front window
needs to be fitted and locks repaired on the front door."

Fiona tapped Salome's arm. "You'll stay with me."

"That's more than generous, Fee, but I'd only put you in jeop-
ardy, too. My mentor, Madame Wu, donated a property to the
Asian-American Women's Association. It's off Dupont Circle.
They have guest rooms, a dining facility, library and such. I have a
lifetime membership. While I've attended lectures there, I've nev-
er had the opportunity to stay over."

From her handbag she retrieved a leather-bound organizer
and her cell phone and excused herself, moving into the adjacent
room where Fiona put together her documentary films. After
making several telephone calls, she rejoined her friends in the liv-
ing room.

"I left messages for the contractor and restorer, conveniently
they are married, and my insurance agent. And I'm all set at the
AAWA for a week."

"What about a car?" Fiona asked. "Didn't you just take yours
in for servicing?"

True, just yesterday, she took the Austin-Healey into Foreign
Service in McLean for its annual tune-up. Her mechanic and the
shop's owner, Dario Burgos, also a tango partner and sometime
lover, had not been available. Had he been, she no doubt would

have been given a loaner. Instead, she had taken a cab home and immediately plunged into preparations for the Friday night presentation, unconcerned about personal transport.

"I'll just take cabs until the Healey's ready."

"How about, I take you to a rental agency?" Jude suggested.

"Thanks but I'd rather get myself settled in. I wouldn't say no to a ride to the club, though."

Jude rose to his feet. "Good. That'll give us an opportunity to talk."

The three went outside.

"Let me just check and see how things are going," Jude said and trotted back to her house, disappearing inside.

"Could be, some crazy kids did this," Salome said, sounding more pitifully hopeful than convinced.

"Not likely, luv. Please, don't succumb to denial! Duncan Mah or whatever he calls himself these days, he's your villain. Young vandals wouldn't be the least interested in this obscure little Georgetown cul-de-sac."

They regarded the two-hundred-year-old Federalist homes that comprised the Close.

The large manor house at the base of the cul-de-sac, where Mah had lived, had been empty for a year while attorneys fought over the sale. Salome herself had put in a bid on the property.

"Vandals are basically cowards," Fiona said. Salome wondered vaguely if Fiona spoke from experience, recalling a chapter of her own youth. "They might throw a brick or two through the windows of the empty manor house but more likely they'd use it as a canvas for graffiti. Same with the Richmans' place," she said, nodding to the house directly across from her own. Though Fiona still referred to it as "the Richmans' place," the Richmans being Arkansans who had worked in the Clinton administration, the couple had finally sold the house to an oil lobbyist. Salome had never met the new owner, just heard about him—and his wild weekend parties—from Fiona when they chatted periodically over the winter. And it didn't appear Salome would meet him any

time soon. The previous month he'd been indicted for tax evasion. Since then the house remained empty of activity.

Fiona pivoted to look at Ruby Nelson's prim town house opposite Salome's. A resident for over fifty years, Ruby had nearly lost the place to Duncan Mah when he invaded their turf the previous spring claiming to be the heir of the newly deceased owner of the manor house. He had gifted the septuagenarian Ruby Nelson with a love-boat cruise as part of a deal to buy her house. Mah had been exposed as a con man and fraud, and Ruby had been lucky not to end up homeless.

"She left Monday to visit her sister in Fredericksburg. Ask me, I think someone's been watching the Close. If Ruby had been home she would have spotted them and called the cops. Not that they would have been arrested but they might have thought twice about showing undue interest. These days, anyone acting suspiciously can't get away with it quite so easily—certainly not in the District."

"What about you? Have you seen anyone hanging around?"

"Sorry, I haven't been paying attention," she said and made a face. After a moment's hesitation she continued.

"Jude and I were in the living room when we heard the glass shatter. He was out of the room in a flash. Chased the car for several blocks. I grabbed my camera and then, like I told you, called nine-one-one.

"Jude's been coming and going through the back alley and parks several blocks away. Just in case. Most likely, any watcher hasn't seen him."

"Just in case?"

"You haven't heard? His wife, Cookie, has filed for divorce."

"Oh, right. She told me last time I talked to her."

"Jude didn't want me dragged into it. In case she decides to get nasty. Anyway, if it comes to light that we've been seeing each other, we have a story cooked up about him helping me with research on a film. Still, no sense advertising the fact, hence the back door policy."

Salome now noticed her Feng Shui paraphernalia beside the stoop and asked if she might leave them for the time being. Fiona agreed and the two women carried all but the tackle box into an anteroom.

A few minutes later, Jude and Salome took their leave, heading around the south side of Fiona's house, into the alley and then up to the street. Jude carried Salome's suitcase and she carried her tackle box to his car, parked outside Holy Trinity church on Prospect. Neither spoke, both watchful and alert.

Inside his car she gave him the address of the Asian-American Women's Association, the location off Dupont Circle. Before heading east, he took a circuitous spin through Georgetown, frequently checking the rearview mirrors. Respecting his grim intensity, Salome refrained from speaking until he relaxed a bit, obviously satisfied they weren't being tailed, and sped down Massachusetts Avenue.

"Germaine Brilliante, the woman I was with tonight," Salome began, avoiding mention of Jude's daughter, Chimene, and why she had been with Germaine, "recently followed April McGann for two weeks at the behest of April's sister June."

"What for?"

"Good question. June didn't give Germaine any specific reason, just hired her to tail April. Makes me wonder if June McGann suspects that Duncan Mah–James Wong is back in her sister's life. Of course, it could have nothing at all to do with Mah. Still, it would be worth it to talk to Germaine."

"She a PI?"

"Former reporter and old college buddy of June. June trusted her to keep quiet. Paid her cash so there's no paper trail. You never know, she might even have spotted Mah."

"Christ! Get her on the phone!"

"Now? It's nearly midnight."

"So what? The wicked don't rest, why should we?"

"Jude, I need to settle in and settle down. But she did say she's a night owl. I'll call and arrange a time to meet."

Pulling cell phone and notebook from her shoulder bag, Salome punched in the numbers for Germaine's cell phone. Germaine answered immediately.

"Sorry to bother you at this hour," Salome began. Jude gave her a slightly annoyed look.

"No problem."

Salome asked if she and Judah could meet with her to discuss a matter Germaine might be able to help them with.

"If you're available sometime tomorrow, may we drop by?"

"Sure. How about the morning?"

"Is nine too early?"

"That'll be fine," Germaine said and gave her directions to the Crystal City apartment building.

"Nine it is then. We'll bring breakfast."

Jude gave her a thumbs-up.

Tucking her notebook and cell phone in her bag, Salome said, "Fiona told me you chased the people who set the fire."

"Got the license plate number. First cop on the scene ran it. As you would expect, the vehicle had been reported stolen. By now the car's probably been dumped."

"Did you see the occupants?"

"Not the driver. A Chinese guy, probably mid-to-late-twenties looked back just as the car turned the corner out of the Close. I have a pretty good memory for faces and might recognize him in a lineup but I'm afraid that, except for the guys I worked with on the force, I can't always distinguish one Asian male from another. Not very politically correct of me. Given Mah's supply of illegal aliens, these two were probably working off their debt. Even if they're picked up, it's unlikely they'll talk."

Salome remembered one lovely young Chinese woman she had seen working in a shop Mah had leased in Georgetown. The next time Salome had encountered the young woman, she had been attempting to steal the jewelry of April McGann, the wealthy socialite Germaine had been hired to follow. Salome had tackled the young woman and endured a painful kick in the head,

which secured her a place in Salome's memory. But the event underscored the treacherous nature of Duncan Mah and his business—corrupting the lives of hopeful immigrants by forcing them to do his dirty work.

Salome sighed, then said in a tone more hopeful than anything else, "What if it was a random act and Duncan Mah had nothing to do with it?"

"Get real, Mei. Experience says otherwise. But anything's possible. Still, why choose a remote little cul-de-sac like Malabar Close? Why choose your house in particular? Is it coincidence that Duncan Mah was once your neighbor? Coincidence that an Asian guy happened to be in the passenger seat, most likely the one who tossed the firebomb? When the arrows all point in the same direction, I tend to take that road."

For such a world-famous city, full of energy and intrigue, Washington, D.C. could feel quite snuggly small-town in certain residential areas. Even in the Dupont Circle area on a Friday night, where Jude now drove along quiet, leafy streets past stately homes and unpretentious mansions in which obscure countries housed their embassies, a sense of "neighborhood" and all that implied managed to exist.

Finally, he turned into the horseshoe drive fronting a large brick three-story mansion painted deep red with black trim. He parked beneath the jutting, well-lighted porte cochere. Through the glass double doors could be seen a glittering chandelier suspended above an enormous arrangement of fresh flowers and a reception desk beyond.

They exited the car and Jude pulled her two bags from the trunk. Together they walked up the wide steps. Salome pressed a buzzer on an intercom beneath a discreet brass plate on which was engraved ASIAN-AMERICAN WOMEN'S ASSOCIATION. A disembodied voice said, "Please state your name and how we may be of assistance."

Salome did so and was told someone would be with her momentarily.

"I know it's none of my business, Mei, but are you planning to call Gabe?"

"You know how he hates interruptions when he's working."

"He really does need to know about the fire. After all, he has emotional if not financial attachments to the place."

"Right."

A tall private security guard approached. Jude and Salome agreed on a time for him to pick her up in the morning.

Jude lingered as the guard unlocked the door. "You sure you're gonna be okay here?"

"I'll be fine."

Still, he waited until she entered and the door locked behind her before he left.

Pausing only long enough to set down her bags in her room, Salome stripped and entered the shower where a stiff loofah, lavender-and-mint ShiKai body wash, shampoo, and conditioner helped dissolve the negative energy she'd accumulated in the last couple of hours. A good toothbrush and toothpaste were provided along with ShiKai lotion, which she lavished on her limbs after a rubdown with the thick Turkish towel.

While combing her waist-length black hair, she padded into the room and opened the suitcase, curious about what Nathan chose to pack. On top were tennis shoes and beneath them a gray sweatshirt and jeans. Taking up the remaining space was underwear. Apparently, he had simply dumped two drawers of silky underpants, bras, and socks. In a side pocket she found the white kid pouch of jewelry. Given all the underwear and a simple change of clothes, she reasoned that an airline had once lost Nathan's luggage.

She put the clothes in one of the drawers of the black lacquered armoire. Behind the doors of the top half she found the television and DVD player. When pointing out the club's amenities, the clerk mentioned that feature and documentary films plus yoga and tai chi instructional DVDs were available in the library,

where she would also find a variety of Chinese, Japanese, American, and British newspapers. A laundry was in the basement. There were no exercise facilities, however each guest room came equipped with a yoga mat. She located the mat in the small closet where she stowed the suitcase.

Taking the treasured teapot from her bag she washed and dried it in the bathroom and placed it on the desk located in the room's knowledge and spirituality gua beside a bouquet of fresh freesias, their perfume adding to the room's uplifting ch'i.

The queen-size bed was auspiciously positioned at a diagonal from the entry door. She ran her hands across the luxurious pearl gray satin bedspread. Notably, there was no clock on either of the paired rosewood nightstands, just two identical lamps with porcelain Kwan Yin figures at the base supporting delicate silk shades in pale pink with gray accents.

She crawled into bed. Her body sufficiently relaxed, she doubted she would have trouble sleeping. She'd requested a seven A.M. wake-up call. A continental breakfast, the clerk had said, would be available beginning at six A.M. and light lunch at eleven. Though the club did not provide dinner, guests could enjoy a complimentary glass of wine and hors d'ouvres between five and seven P.M. None of the guest rooms had refrigerators or honor bars.

She switched off the bedside lamps and laid her head on the small pillow. She said her prayers and tried to clear her mind, but certain thoughts would not go away.

Fiona had mentioned retribution. Salome had avoided discussing it. Retribution, revenge was a personal matter. Personalizing what Duncan Mah had done to her would make her twice a victim—by him and then by herself to herself. If she knew and understood one thing about Feng Shui it was the profound importance of intentions: even the loftiest ambitions would be slow in coming and less pronounced without the addition, the thrust, of personal intentions. Revenge was an evil intention that hurt both the target and the shooter.

No, she would regard the unearthing of Duncan Mah as business. She would revert to her pre–Feng Shui years when she researched her ex-husband's mystery novels. She had been the one who determined the correct investigative procedures Gabriel used (or in some cases, distorted to suit his characters and story) in his books. Twenty years' experience gave her confidence that she was up to the task.

Naturally enough, she would ally investigative experience with Feng Shui skills. Switching the light back on, she got out of bed. In the tackle box she found a gorgeous blue thirty-millimeter faceted crystal already threaded with a nine-inch length of red cord. She hung it on the shade of the lamp on the desk in the knowledge/spirituality gua. She performed the Three Secrets ritual, hands in the proper mudra at her waist, chanting the six perfect words along with her intentions, while visualizing the desired outcome: Duncan Mah in the hands of the proper authorities.

Carrying the desk chair to the helpful people/travel gua, she used a tack to hang a lightweight wooden flute from a red cord to "send out the call," the mouth angled toward the floor. Again she performed the Three Secrets ritual, now calling upon assistance from others. Though their identities were unknown, more important in her visualization, they provided information that created a trail to Duncan Mah's doorstep.

Returning to bed, she now felt a certain satisfaction that in this small way her efforts had begun, not to take revenge, but to serve justice.

And indeed, certain energies were already in motion. She need not have worried about disturbing her ex-husband, for within hours, he would play a part, his entrance quite dramatic.

Chapter Eight

NO WONDER Germaine is in career limbo, Salome thought soon after stepping over the threshold of the Crystal City apartment. Behind her Germaine put extra effort into closing the heavy front door.

"Why not have maintenance fix that," Salome offered, unable to resist. "The door is in your career gua, the symbology suggesting being stuck."

"It's been a problem for weeks now. Given all the rain lately, I figured the wood expanded. Not much I can do about that." Finally, with a grunt, Germaine managed to close it and secure the deadbolt.

An antique armoire, too big for the small foyer, took up most of the space. A hallway branched off to the right, a short passage to the left.

Salome reintroduced Jude while Germaine took his windbreaker and hung it inside the massive antique.

"So, you're the private investigator Salome told me about," she said. The pair shook hands. "Well, I hope I can help. And I don't mind saying, maybe you can help me out, too."

Salome handed her the large bag of pastries and croissants bought at a bakery in Dupont Circle. Germaine opened the bag and released the warm, yeasty scent. "Smells great," she said. "Well, come on in. I'd say pardon the mess, but that would imply that it's temporary."

Moving left, they entered a huge living room. Salome's attention was divided between the spectacular view from the wrap-

around west and north glass walls and the incredible jumble of furnishings.

Upon reaching the north side, Germaine excused herself to get the coffee. Washington, spread before them like a vast architectural gallery, the Capitol dome and monuments banked by spring foliage and bathed in the clear morning light, gave the impression that only the purest of values and most admirable intentions were at work on the other side of the Potomac.

Though she admired the vista, the tug of the interior was too much for Salome. She turned around while Jude looked out, clearly entranced.

The sheer number, variety, and size of the furnishings told her that Germaine was less the tenant here than she was the caretaker. "Warehouse" seemed the most suitable word to describe the space. Lamps, with and without shades and bulbs, bedroom suites, two dining room tables with matching chairs upended on the surface, were included with several sofas, coffee tables, hutches, and among other items, a huge mantelpiece propped at an angle in the relationships gua.

Germaine appeared carrying a laden tray. She looked around for a moment, then set the tray down on a coffee table covered in blue-and-green mosaic tiles that had a look of the 1960s.

"Help yourselves," she said, "while I scout a place to sit."

Once they were settled at an eight-seater dining table in the center of the room, each with a steaming cup and pastry, Germaine answered the unspoken question.

"To save money, Mother decided to store her furniture here while she looks for a house in Florida. Since my dad's death, she's been rattling around the big family home in Fairfax all by her lonesome. We tried living together when I moved back to the area. Big mistake." She waved her hand dismissively. "Anyway, what can I help you with?"

"Anything you can tell us about April McGann."

"Jesus! That's supposed to be confidential." She frowned at Salome.

"And will remain so," Jude said, his voice resonant with authority. "For over a year now, Salome's been harassed by April McGann's former fiancé, James Wong, but better known as Duncan Mah. We think he's responsible for the fire at Salome's house last night."

Germaine looked thoughtful. "Asian guy, right?"

Both Jude and Salome straightened.

"You've seen him?" Salome lowered her coffee cup.

"No, no," she said quickly. "It's just that June asked me if I'd seen a handsome Asian man with April or near her. She gave me very little information, only that she wanted April followed for two weeks. Wouldn't tell me why. Then, after I showed her the photographs I'd taken she asked about an Asian guy."

"Where are the photos?" Jude asked.

"They were burned. And I left the negatives with June. She probably burned them, too."

Jude sat back in his chair and let out a breath.

"But," Germaine said with a smile, "I have all my notes."

She left the room momentarily, returning with a frayed green notebook. Flipping through the pages to refresh her memory, she recounted her days surveilling April McGann. As she had done with June, she saved the most significant event for last.

"Black Friar's Books?" Jude said. "Interesting. Last time I recall hearing about the place was a good ten years ago. Blackie Friar ran a gambling operation out of the town house while his brother took care of the bookstore. Catered to local college kids. They even had a couple coeds on the payroll who turned tricks for extra money. Second District cops busted them. But only Blackie did time."

Jude smiled at Germaine. "Good job."

Germaine brightened. "You don't think I was an idiot for stumbling into April?"

"It happens. And you went two weeks without being noticed."

Germaine snorted. "In middle age, women tend to fade into the background."

"Roger that," Salome added.

Jude laughed. "Which makes middle-aged women highly suited for investigative work. Emphasize your assets, Ms. Brilliante, even when they don't seem complimentary."

"I just need something to do while I figure out what to do with the rest of my life."

"How about starting now by writing a comprehensive report of your time spent tailing April McGann? What Mies van der Rohe said so succinctly about architecture applies equally to an investigation: God is in the details."

Germaine frowned. "Is this ethical?"

For all the indignation expressed during the drive from the Women's Place, when confronted with the reality of actually doing something, Germaine balked. Salome wondered if she and Jude had moved too fast and should have begun by providing the woman with more background on their investigation.

"You mean, being paid twice for the same job?" Jude asked.

"June didn't want a written report—instructed me specifically not to write anything down."

Salome decided to step in. "Have you heard of the Tres Soeurs necklace?"

"Sure. I saw it in a photograph June kept on her desk in college. Her parents were at some function at the White House with John and Jackie Kennedy. Mrs. McGann was wearing the necklace. I don't know if it was Mrs. McGann herself or her jewels, but the president couldn't take his eyes off her."

"Perhaps you should know something about April McGann's former fiancé."

"This guy, Duncan Mah?"

"Also known as James Wong. Last year my mentor, Madame Wu, wangled an invitation to April McGann's birthday party with the objective that April would take me on as her Feng Shui consultant. There, I was shocked to learn that Duncan Mah, my new neighbor, was engaged to marry April."

Salome took a sip of coffee. "I'll jump to the pertinent points. I

saw him attempting to steal the Tres Soeurs necklace just after his accomplice tried and ran off. He denied it and April believed him, but it earned me his animosity.

"You see, he came to Washington posing as Duncan Mah, a dealer in Chinese art and antiquities, claiming to have inherited the manor house, as I said, in Malabar Close. Just before April and Mah were to marry, the body of the real Duncan Mah was found in San Francisco, where he'd been murdered. The impostor disappeared and we learned that he was really a white slaver—what the Chinese call a Snakehead—by the name of James Wong. Obviously he was worming his way into one of the District's most wealthy families. What a cozy place to establish his own criminal empire. When you think about it you can see that he would have access to America's movers and shakers, and with such great wealth at his fingertips, insidiously spread his corruption."

"Yike! Now I can see a motive for June. She's pretty much in charge of the family money. June would be livid if an interloper tried to take control. For all her good works, June's tightfisted. One elderly woman takes care of the whole house in McLean." She looked away for a moment. "No, that's not exactly right. June's hired an organizer. I don't know how often the woman comes in. Apparently organizers are flavor-of-the-month." She looked at Salome. "Competition for you, I imagine."

Salome shrugged. "Reduction of clutter is integral to both professions. For those who find Feng Shui a bit too exotic, an organizer's work is easily understood."

Germaine cast sad eyes on the furnishings crowded around them.

Salome asked, "Do you have a storage unit?"

"In the basement. That's where *my* things are. Sold most of my stuff last spring and went to Taos. In search of enlightenment." Her short laugh was edged with bitterness. "Cost me a bundle and I'm no more enlightened than when I started. Maybe less so."

Recovering, and looking more resolute, she confronted Jude. "You mind talking money for a moment?"

After a short discussion, the pair settled on a price for the written report, plus payment to continue following April, and Jude mentioned that she would have to alter her appearance. "Except," Jude said, "at the gym. If she previously noticed you at the gym, you'd only call attention to yourself by adding a wig or glasses."

Returning to the subject of Duncan Mah, Salome continued. "While I'm sure Mah has bigger fish to fry, he's definitely made it clear since April's party that I'm on his radar. Jude has clocked the most miles trying to track him down—making several trips to San Francisco and as far afield as Montreal and Victoria, British Columbia."

Jude regarded Germaine. "June McGann never told you about April's engagement?"

"Not a word. And of course, I didn't move back here until last November." Her attention dropped to her lap.

"You've been living like this since then?" Salome asked.

"December, actually. That's when Mother sold the house."

Salome looked across the table at Jude. "We need to think about leaving." The contractor, restorer, and insurance agent had agreed, after some early calls, to meet at the house at around ten-thirty.

Jude nodded and rose. "Great coffee."

"Having drunk so much bad coffee in various newsrooms, I taught myself how to make a good brew."

Germaine led her guests through the maze of furniture to the foyer.

"Let me help," Jude offered as Germaine struggled with the door. She stepped aside. Though stronger than Germaine, he had problems with the door, too. With a mighty yank, he finally opened it fully, then took a moment to examine both the door and frame.

"I doubt this is the original door. It's a little too big for the

frame. These apartments must cost a pretty penny; no reason you can't have it replaced."

"And Germaine, it's just an idea, but you might want to move that mantelpiece out of the relationships gua—it is blocking the flow of energy there. Do you still have your Bagua?"

"Oh yeah."

"Bring some of your own things from your storage unit even if you have to make room for them."

Jude and Salome thanked her for her time and they agreed to talk later to establish a schedule.

"Never could understand the draw to Crystal City," Jude remarked as they passed high-rise hotels and apartment buildings. "Unless you like the sterile, combed-air feel of living in a multi-storied bunker. I'll take the District's shabby chic any day."

Soon they were on the George Washington Parkway heading back to Georgetown, which they would enter via Key Bridge, named for Francis Scott Key, author of the national anthem, a fact that even many locals did not know.

"Think she'll work out?"

"Yeah, though working for me, she's not going to make rent on that place."

"She's thinking about writing a book about the McGann family."

"That'll keep her occupied for a decade or so." He glanced over at her for a moment. "Look, your plate's pretty full now, what with all the work that'll have to be done on your house, so why don't you let me take care of finding Mah."

Off to the right a silver 727 flew low over the Potomac, preparing for landing at Reagan National Airport.

Salome said sharply, "Damn, Jude, don't worry about me. It's time I made room on my plate. No, I'm in all the way."

"To the bitter end?"

"Whatever the flavor."

Chapter Nine

ROUGHLY TEN miles west of Crystal City, in an exclusive enclave of McLean, Virginia, Gabriel Hoya paced in front of his desk, barely giving the minute hand on his Rolex time to make a full circle before checking it again. Honey Lee should have arrived promptly at nine, forty-four minutes ago. Efficient, fastidious, and *punctual*, that was Honey Lee. Until today.

Gabriel came to the wall, took a deep breath, and turned around, now facing the ViewSonic 17.4-inch LCD monitor pivoted to the top-to-bottom feature that allowed him to see the screen just as the printed page would be. Despite his upgraded equipment his writing hadn't improved. On the screen were two paragraphs he'd written yesterday. He could not start today's work until Lee arrived. If he was on a roll and the doorbell interrupted his concentration, he'd have to grapple and agonize to regain the groove. So it was best to wait for her, let her in, lock the office door, and forget her presence in the house. Of course, that in itself was hard enough. His mind always wandered to what she was doing. He could imagine her laundering, ironing, and folding his underpants, then tucking them neatly into the "underpants" drawer. Except for one longtime maid, no one who hadn't either birthed him or joined him in marriage touched his underwear. Lee not only touched it, she took it from the hamper, put it in the washer, then in the dryer, plucked it from the dryer, ironed it, folded it, then placed it in its designated drawer.

Never in his fifty-plus years had he given a thought to socks

and Jockey shorts and T-shirts and whatnot all getting together in the same dresser drawer. Until Honey Lee, the Underwear Nazi. Since her first day on the job nine months ago, she made him feel like a carpet mite, a dust bunny, *unclean.*

He had to admit that she was attractive. But if one looked at her long enough, one could sense something odd about her. However, Gabriel usually became so flustered when she was around, he couldn't use his reasonably efficient deductive powers to figure her out and analyze her as he did his characters. *Did. Had once done.*

His current crops of fictitious folk were about as differentiated and multidimensional as cornflakes.

Elle, his increasingly busy wife of a year and a half, had hired Lee to organize the household, shop, and do the laundry three times a week. Mary Jesús, the maid who had worked for Gabriel for over twenty years, came on Thursdays to take care of the major cleaning chores. Even with his domestically challenged wife away from home from early morning to early evening, they could have done very well without Lee. But as he'd learned, "everyone" now had an Organizer. There was even a national organization of Organizers. And if "everyone" had one, Elle had to have one. It was a matter of social maintenance.

In midstride, he abruptly remembered the grocery list Elle had given him to give to Honey. Normally Elle didn't trust him to remember such a simple thing—he had a habit of losing himself in his fictional world, in itself quite natural for one who made a living from his creative mind. But last night Elle had decided to give an impromptu dinner party for some of her friends tonight. He frowned, recalling the 7:30 A.M. encounter with his wife.

"Sweet beet!" Elle had practically yelled into his ear while hovering over his prone form, his head cocooned in a down pillow and bedclothes. Crossing over from dream-state to reality had never been an easy or quick transition for him but Elle couldn't wait, and throwing back the covers, pulled him upright.

"Listen carefully," she crowed, waving a sheet of paper in his

face. "This is a grocery list for Honey. I want you to give it to her as soon as she arrives. She needs to cook for tonight's dinner party. Got that? *As soon as she arrives!*"

"Uh-huh."

Elle had turned around and fussed with her hair and preened and regarded herself from every angle in the twelve-foot mirror covering her personal walk-in closet.

Gabriel tried to focus on the sheet of paper in his lap. "Why not call her and tell her you put it on the kitchen counter or something?"

"I did call. Home phone and cell. No answer. Now I have *got* to get going."

She bent down and brushed his cheek with her own. To kiss him might have smeared her lipstick. She strode across the wide expanse of white carpet. As she passed through the doorway she hollered, "Don't forget!"

With that final admonition in mind, Gabriel shuffled through the papers strewn across his desk. Not finding it, he glanced around the room. Logically he would have left it on the kitchen counter when he'd gone downstairs to make a pot of coffee. Still, whatever he'd done with the list hadn't imprinted itself on his mind with enough force for him to remember. His characters usually took over as soon as he got out of bed.

He hurried downstairs, hoping Elle had included Honey's phone number on the list. Now he wanted to call the woman to see what was keeping her.

"Goddamn list and now a phone number," he grumbled, hating these petty incidents that took him from his work.

A six-foot by six-foot marble-top island with a four-burner inset and stools along two sides dominated the kitchen. He scanned the surface. Elle's catalogues and magazines were scattered along one side opposite the stovetop. Sections of the morning *Washington Post* lay open on the side that was his territory and hadn't been touched since he set it down and read a couple of stories nearly two hours ago.

Gabe padded over to the Bunn coffeemaker alongside the sink full of last night's dishes. The list wasn't there. He poured a fresh cup and moved over to the newspaper. Not allowing himself to be distracted by the news, he lifted the various sections, finally rewarded beneath the classifieds.

"*Voilà!*" he exclaimed, feeling both triumph and relief. Of course, it had been silly to think that Elle might have jotted Lee's phone number on a list she was giving to the woman. Before resorting to calling Elle to ask for the number, he went to her personal directory, the refrigerator. He scanned a dozen-plus yellow sticky notes further affixed with round happy faces before he found Honey's home and cell numbers.

Carrying his coffee cup, he went to the phone on a long counter above which were four large cupboards filled with Elle's abundant supply of expensive French serving dishes, and all the booze, and called.

"Hi. This is Honey," the familiar voice answered in her warm conversational drawl.

"Hello Hon—Ms. Lee. This is Gabriel—"

"Can't come to phone right now. At beep please leave message and I call to you as soon as I can."

Gabe slammed down the receiver, feeling a right fool for talking to what had been a recorded voice. He picked up the receiver a second time and tried her cell. Another message, but no answer. The woman was infuriating. But he couldn't just wait and stew until she arrived.

Finally, he simply left a message on her home phone. With all the civility he could muster he said, "This is Gabriel Hoya. The time is now ten-sixteen A.M. You have until eleven o'clock to either call or show up. After that time, we will no longer require your services."

He gave the number, then hung up. He rubbed his eyes. Elle would be furious. At the moment he didn't care. Let her learn how to put underwear in a goddamn drawer.

He moved back to his side of the island to wait. He sipped

coffee and had just picked up the paper when the phone rang. Putting his coffee cup down, he answered the phone.

"Hello," he said abruptly, anticipating an apology and excuse in Honey's smooth tones.

"Gabriel." A different voice altogether, this one belonging to Kathryn Ortiz, his literary agent. The last person he wanted to talk to.

"Kathryn." He hoped she didn't hear his nervous swallow.

"Gabriel."

Assuming an insouciant air, he remarked, "Well, now that we've established to whom we're speaking, what's up?"

"Certainly not your career."

"Ah, well. You have anything *new* to talk about?"

"Enough bantering. Last night I finished the manuscript."

"Love Moves," he prompted.

"Bowels move, Gabriel; this, this…so-called romance novel doesn't."

His coffee out of reach, Gabriel looked around for something to drink, anything to moisten his throat.

"A year and a half, I've waited for a book from you, and you send this…this…"

Gabriel opened the cupboard, coming eye-to-eye with a bottle of Cointreau. Drambuie was next. Lee had definitely been in the cupboard.

"Bodice ripper," he supplied gamely.

"Oh, I'll give you that. Bodices *aplenty* are ripped on the heath, in the heather," she went on in a singsong voice, "beside hearths, inside hovels. Unfortunately, bodice ripping in and of itself does not a story make." She paused.

Gabriel reached in the back of the cupboard for the recognizable neck of the bottle of Laphroaig, of which he'd consumed way too much while penning *Love Moves*.

"Gabriel, whatever possessed you to write—*try* to write— romance?"

He took a drink from the bottle, grimacing as he swallowed.

"My wife. She thought it would be thrilling if my name was on the jacket of the books she and her friends read."

"I'd divorce her."

"Well, that's certainly getting to the point," Gabe said, and took another swig, this one going down a bit easier.

"Biggest mistake you made was splitting with your first wife. She was a writer's ideal mate. She supported what you write best, mysteries. As I recall, she even did much of your research. Salome, right?"

"Yeah. *Saint* Salome."

"What are you working on now?" Kathryn asked, the hope in her voice unmistakable.

"The sequel." To his horror, his voice cracked.

Though she did not immediately speak, he could hear her disappointment loud and clear, could even see her pained expression as she sat behind her cluttered desk, manuscripts positioned like stepping-stones to the door of the office on New York City's Fifth Avenue, where she worked, hell, *lived* 24/7.

"Gabriel," she said softly. "In all our years together, have I ever lied to you?"

"Not that I know of." The scotch on his empty stomach tweaked him into a flippant tone and he added, "But probably."

"Well, I haven't! I wouldn't be in business otherwise. The way I see it, you have two options, both doable. Write another mystery or find another agent. I cannot uphold my reputation and yours by representing this dreck!"

He noted she no longer had a problem finding a descriptive noun. Gabriel's skin prickled, the irritated tease before the furious surge.

"If that's the way you feel, then I need to make some calls!" He paused, expecting an instant response. Then he realized that no sound came from other end. Kathryn had hung up on him.

Numbly, he walked to the back window and opened the wooden blinds.

He thought of Jonathan Gash, a favorite author who had

written the delightful series about an antique dealer, Lovejoy, and his merry band of associates. Not long ago, Gabriel had attended a mystery writers' conference in Philadelphia where Gash was a featured speaker. The doctor of tropical medicine turned author spoke frankly and humorously to a crowd of eager listeners. At one point, Gash suggested that authors change agents every seven years, a recommendation that originated from Gash's own agent.

If I had taken that advice at the beginning of my career, Gabriel thought, I'd be well into my third agent by now.

He gazed out between the slats at the empty swimming pool in the back. He'd consented to the pool's construction as a device to attract the stepson he'd spent all of one evening with since he'd married the boy's mother. Elle said Tyler would love to come home from military school and spend time with his "Dad" if a pool was available.

Feeling depressed and regretting having drunk the scotch, Gabriel topped off his coffee and trudged back upstairs.

He sat in his chair and swiveled around to face the monitor. After a moment, he leaned back in his chair and gazed at the ceiling contemplating murder. He inhaled deeply, then positioning his fingers on the keyboard, was just about to erase *Love Moves II*, when the phone rang.

Must be Kathryn calling to apologize, he mused. *Or Lee.*

"Hi, sweet beet."

So much for divining the identity of callers.

"Oh. Hi."

Failing to detect his unhappy state, Elle said, "Did you give the list to Honey?"

"She never showed."

Though he understood her reasoning, he was still annoyed that Elle had called to check up on him. He said he'd left a message on Honey Lee's home machine, leaving out the bit terminating her employment.

"You mean she wasn't at home?"

"How could I know that? I called. Her machine picked up. She may have been there."

"She never *ever* misses an appointment. Go check on her, Gabriel." No more sweet beet. "She might be sick or something."

"I'm working." Or unworking, he thought.

"Her house is only a couple miles away." Elle gave him the address. "Thirty minutes isn't going to change your career."

"Why don't *you* check on her?"

"Because I'm in D.C.! And you're practically next door." After a slight pause she said, "Please?"

Grumbling, he picked up a pen. "What was that address again?"

Elle repeated the street and house number. "Call me on my cell as soon as you find out. We'll go from there."

"This is not going to turn into a day of running errands for you, Elle. I will go to her house. I will return from her house. Period."

"And, Gabe, change into a pair of decent pants before you go!"

The line went dead. Had she even listened to him?

For the second time in a matter of minutes the two most important women in his life had hung up on him without so much as a polite "good-bye" or "talk to you later."

Gabe glared at the monitor. His workday was ruined before he'd had a chance to begin. He shut off the computer and went to the bedroom.

Without changing out of the faded cut-off blue jeans with the gaping hole in the backside, he grabbed his wallet and keys off the dresser and hurried downstairs to the two-car garage.

Behind the wheel of the black '65 Mustang convertible, he used the remote clipped on the visor to open the garage door. While listening to the clatter of the door slowly rising on its tracks, he briefly considered his options as a way to regain some sense that he was in control of his life.

He could drive to his lawyer's office on Duke Street in Alexandria and file for divorce. He could visit his ex-wife, Salome, in

Georgetown. He could check on Lee and find out why she hadn't showed. He could forget women altogether and pick up some beer and crawl into the empty pool and drown his sorrows. Or he could visit his old pal Judah Freeman. The former Metropolitan homicide detective now operated his own private investigations firm from a shabby office on 9th Street in the District. Maybe he could use one of Jude's cases as a basis for a story. Maybe he'd ask Jude for a job. Now there was a concept!

Whatever he did, he thought as he switched on the engine, the garage quiet now that the door was fully open, he needed a change. He needed a *major* change.

Chapter Ten

TIRES SQUEALING, Gabriel peeled up the street, taking the first right too fast. He just missed hitting old Mrs. Rhode, who was walking her yappy terrier. Hunched over and encased in fur, she looked like a bear cub being pulled by a dog. She yelled something at him and he stuck his hand out the window and waved, hoping she'd interpret the gesture as an apology.

When he wrote his mysteries, he would often drive through the hilly Virginia countryside to work out story problems. The car was a good friend and trusted companion and sometimes seemed to drive itself as he let his mind drift while admiring the landscape. Finding a comfort zone in the car, he began to relax.

Looking around at the beautifully manicured emerald green lawns foaming with azaleas, dogwoods, miniature forests of tulips and daffodils, he felt oddly like a tourist in his own backyard. Suddenly he realized that the last time he'd taken a drive the trees were bare, and the ground an ugly patchwork of dirty snow and prickly brown grass.

Spring, he thought. My favorite season and I didn't even know it had arrived. The farther he got from the house, the better he felt. He was glad to be sitting on the black leather bucket seat, connecting again with his car and the world. For the first time in his career life, he didn't have a salable manuscript—didn't have a story, for that matter—and was dangerously close to losing his agent. But for some reason, all that only lifted his mood.

Preoccupied by this new sense of freedom, he nearly drove past Honey Lee's street. He quickly spun the wheel, earning the one-finger salute from the driver just behind him.

This was one of McLean's older, more modest neighborhoods, popular with young first-time buyers and older couples too tired to move.

Slowing, he noted the numbers. Finally he turned into the drive of a brick ranch-style house and parked in front of the single-car garage. He walked up a short, narrow path to the front door and rang the doorbell. While waiting, he turned to look around and noticed an old maple in a direct line with the front door. He half smiled, thinking of Salome: a tree in line with the front door probably meant something in Feng Shui. When no one answered the second tonal summons, he tried the knob. The door was locked. All of the front windows sported drawn curtains.

Since he'd gone to the trouble to come all the way here, he might as well be thorough, and went around to the back, stopping long enough to peer through the pane of glass set into the garage door. Lee's gray late-model Toyota was parked inside.

He passed through a gate that was part of a chain-link fence, which ran down this side of the backyard. Now he began to feel a little edgy. What if she kept a Rottweiler or some other vicious hound? Then, too, what if a neighbor spotted him and called the cops? Given his description, they'd know this was no meter-reader: Some tall so-and-so with his butt hanging out, wearing a T-shirt with an Archie Goodwin quote: GO TO HELL! I'M READING. And dressed thusly, he probably was no friend of the immaculate Honey Lee.

He hurried to the stoop outside the back door, trying to look like a man on a friendly mission, glad, too, that no slavering animal had charged him. His forceful knock rattled the door's glass pane. Two ruffled yellow-checked curtains were pulled aside, giving him a somewhat restricted view of a spotless electric stove with a hood, some cupboards and a counter, but no Honey Lee.

Stepping down onto the thick grass, he surveyed the back of the house. Pretty blue and pink petunias filled two window boxes at the windows beside the door. Blinds were drawn at each. A window on the far right and another on the far left had interior shutters, both closed to the morning light. There were four ground-level basement windows, two on either side of the porch. He squatted down and peered through the nearest one on the left, at first being met by his own reflection. Then he frowned. There was something odd behind his face. His first impression was of a double exposure of two disparate images. He moved closer and cupped his hands on each side of his head. He blinked. He frowned. Then his eyes widened and he absorbed the details of the scene before him.

Honey Lee hung by a short rope from a metal rod. In a clinical way, he noted that *livor mortis* had tinted her hands and bare feet purple. The cloudy eyes and the tongue sticking out between her lips further told him she was dead, though the fact had not impacted him yet.

The overturned folding metal stepladder on the concrete floor below her feet suggested Lee's final act. A pair of expensive leather scuffs had fallen between the rungs. The dry floor suggested that her bladder had not voided. In death, as in life, the little Organizer looked neat and carefully groomed.

Directly below the window and in front of the corpse were a washer and dryer. A half dozen inflatable hangers hung to the right of the corpse. Anyone not given to probing would consider the basement and its accoutrements a fitting place for such a person to end her life.

He looked away, thinking his imagination might be in overdrive. But when he looked back, nothing in the basement had changed.

For a brief moment Gabriel drew from a fictional favorite, Colin Dexter's Inspector Morse. Morse had said something to Sergeant Lewis that Gabe that had never forgotten, an adage that

bubbled up whenever he puzzled over a story problem. *"Why, Lewis," Morse said. "Always ask why."*

Finally it sunk in: he had found a dead body! Scrambling to his feet, Gabriel collided with the flower box directly overhead. He yelped in pain.

Wincing, his hand poised over the throbbing spot, he stumbled out of the backyard to his car, trying to remember the name of the Fairfax County homicide detective who for years had been a drinking buddy. But pain blocked access to his memory circuits. He stood very still and closed his eyes until the pain began to recede. Gingerly he touched his scalp, then looked at his hand. Though he expected it to come away dripping blood, none appeared.

He reached in the open passenger window and grabbed the receiver of his car phone. For a brief moment he considered calling Judah, more because he was a close friend and Gabe wished mightily he had a friend with him. Practical considerations finally kicked in and he called 911.

Once he had made the call, he noticed a neighbor across the street step onto her porch and stare at him. He ignored her and took several deep breaths. Had he really just seen a woman hanging by her neck, definitely dead? Good God, he thought, had Honey killed herself? For a moment he couldn't move. Then realizing that a full complement of EMS personnel—ambulance, fire, police—would be arriving any minute, he got into the car and drove down the street, leaving the space around Lee's house open.

He waited behind the wheel, his mind suddenly a hive of activity. Gradually he began to realize what he had. Color infused his pale cheeks and his eyes grew large and bright. The pain in his head diminished to a distant drumbeat. His gut told the tale with that unmistakable clutch, a sensation he'd not experienced for far too long.

What was it Elle had said? *Thirty minutes won't change your career!*

"Wrong!" he hooted.

He heard the approaching sirens and exited the car, confident, strong again. He almost waved to the woman on the porch but had sense enough not to show his joy.

He had a *story*!

Chapter Eleven

THE CONTRACTOR, Jim Selsor, was inspecting the exterior of the house when Jude and Salome pulled into Malabar Close. Jim's wife, Hillary, a successful restorer of historic Washington homes, chatted with the insurance agent, Vernon Sax, beside the Selsors' shiny red Ford pickup, which dwarfed Vernon's VW.

Jude swung around the cul-de-sac and parked in front of Fiona's house. "Come over to Fee's when you're finished," Jude said. "In the meantime, I'll make some calls."

Suppressing distress at the sight of her wounded home, Salome joined Vernon and the Selsors while Jude carried the sandwiches and soft drinks they'd stopped to buy on the way over to the patrol car parked in front of the manor house.

"Thanks so much for coming on a Saturday," Salome said and shook hands with all three.

"You know Hill and me, Salome," Jim said, "we think of these little gems as our patients." Both he and his wife were dressed casually in rubber boots, jeans, and lightweight shirts and windbreakers, and carried clipboards. Vernon, as always, was dressed for the office in khaki pants, a blue shirt, striped rep tie, and navy blazer. Salome felt reassured by his unhappy expression—he would be forking over a hefty payment.

All three had already read the damage report, which Vernon had picked up earlier, and were anxious to determine the amount of work to be done and assess the costs and time involved.

Salome led the way around the back. Pulling her keys from her

handbag, she unlocked the back door and they entered the kitch-en. Salome winced at the lingering charred smell but the others seemed unaffected.

As Vernon, Jim, and Hillary examined the fire-blackened front room, Salome leapfrogged reality, envisioning walls of robin's egg blue. This being the knowledge and spirituality gua, she would honor the space with such items as would stimulate work on her Feng Shui Casebook, which now must rise from the ashes. She visualized a mandala of her own creation framed and hanging above a round table containing a special pen and her favorite Feng Shui books.

"Salome?" Vernon said. "You with us?"

"Just thinking ahead."

For the next hour they examined the house from the third floor study, where Salome kept her computer and Feng Shui sup-plies, to the basement housing the furnace, some tools, her washer and dryer, Gabriel's battle-scarred walnut desk, and various boxes of his belongings. Structural damage was confined to the front room to the left of the foyer, the adjacent dining room, and the ceiling. Moldings and wainscoting needed replacing, as did the water-damaged hardwood floors. Most of the work would entail industrial-strength cleaning and new paint throughout. Jim said he would also take care of having the carpet on the stairs cleaned and refitted, and provide security as long as necessary.

Salome reminded herself that she had returned to Georgetown with renovation in mind. The fire hadn't altered her intentions, just pressed her for decisions.

Returning to the kitchen, they sat at the round table in the breakfast nook and discussed costs. Vernon had been her east coast insurance agent for over twenty-five years, since she and Gabriel had first lived in the town house as newlyweds. As a mat-ter of course, Salome never scrimped on property insurance. The combination of factors made for a hassle-free business trans-action.

Finally, Jim asked, "One other thing, what do you want to do

with the furniture? It needs to be out of the way while we're working. My grandson and a buddy at George Washington have a moving business, weekends and evenings. I could probably get him over here this afternoon or tomorrow morning. The basement needs a thorough cleaning but you can still use it for storage and we'll save cleaning it for last—or the boys can take everything to a storage facility, whatever you want."

Salome thought for a moment. "Let me make a couple of calls first. I'll just be a minute."

Standing at the sink looking out on the back garden, Salome first called Germaine and asked for the number for the Women's Place.

"Hey, I've got some news," Germaine said excitedly.

"Look, I'm kind of busy with the contractor right now. How about, you tell me over dinner?"

"Sure."

"I'll call you later and we'll set up a time and place."

Louvee answered on the first ring.

"Hi Louvee, this is Salome Waterhouse. How would you like some new furniture for the Women's Place—well, not exactly new, but it's in excellent condition."

"I'll need to get an approval first."

"How long will that take?"

"Could take a couple weeks. I mean, there are people who think they're doing us a favor by dumping all the stuff they don't want. We have to be careful. We're not the Salvation Army."

Back in the breakfast nook, she asked Jim to contact his grandson to move everything and asked if they would also secure a storage unit. Jim said he'd take care of it.

Once the insurance issues were more or less settled and Vernon had her address at AAWA, he left. Salome, Jim, and Hillary moved outside to the back garden where they discussed her plans for new landscaping. Birds in the ornamental cherry tree chirruped happily, the noise a reminder that life quickly reestablishes

itself in the wake of disasters both big and small.

"Sounds like you've been giving some thought to changes," Jim noted.

Salome smiled ruefully. "Sometimes misfortunes occur when change is overdue, when we haven't been paying attention. My work requires me to focus on other people's problems. This fire reminded me I'd best spend some time taking care of my own business."

Jim called his grandson and arranged for the furniture to be picked up at eight o'clock the following morning. Jim himself would arrive at the house at the same time with a skeleton crew to begin work. He assured her he'd have a full crew starting first thing Monday morning, and while he couldn't make guarantees, he proposed to finish with the major repairs and general clean-up in ten to fourteen days. Interior painting could be done in three to four days after that. Then Hillary would see to providing replicas of the living room's original moldings, wainscoting, and mantel-piece.

After the Selsors drove off, Salome went over to Fiona's.

"Come on in, Mei. Jude's on the phone. You hungry?"

"Far from it," Salome groaned.

"The bill?"

"It's substantial all right, but insurance covers most every-thing. Remodeling, major repairs upset the balance in people's lives, Fee. And the disruptive energy will affect you, too, because of proximity."

"No worries, Mei. Disruption is my life."

"Let me implement some Feng Shui protections for you."

"I appreciate that, but no—and I don't mean to imply that I don't believe in your abilities—I just think you need to focus your efforts on yourself, in cleaning out the clutter called Duncan Mah. You do that, we'll all benefit."

Looking confident, crisp, and ready for action, Jude strode into the room. In fact, Salome could not remember the last time he

had looked as good or better. Something quite extraordinary had happened to him. No longer was he the floundering, angst-driven private investigator trying to find his legs since retirement from the Metropolitan police force. This was not the same man who had suffered so greatly when his beloved wife of thirty years, Cookie, asked for a separation over two years ago.

He put his hands in the pockets of his tan slacks and looked at Salome. "Well, kiddo, we have an appointment at three o'clock with April McGann."

"We?" Salome's eyes widened in surprise.

"As in you and me."

"Yes, but how'd you manage? Given that the last time she and I had a face-to-face, her thoughts ran more to murder." Salome looked thoughtful. "But maybe that's still on her agenda."

Jude laughed and leaned against the mantel above the fireplace. "She's expecting me and my partner. Didn't seem necessary to give my partner's name."

Chapter Twelve

FINALLY EXTRACTING himself from the mob at Lee's house, Gabe drove away. Somehow, he'd managed to take the EMS personnel to the basement window in the backyard, desperate for a notebook and pen, part of his mind transferring the reality to New Orleans, where his fictional sleuth, Antoinette de Beauharnais, conspicuously consumed all that city had to offer. The Garden District? Maybe a seamier side of town. Lots to choose from there. While they broke into the house, he had to stay with his car and talk to the reporters who suddenly appeared as mysteriously as fruit flies to ripe bananas.

Two blocks later he pulled over to the side of the road. After shutting off the engine he rummaged in the backseat for a notebook. With a pen found in the glove compartment, he began scribbling notes. After a few moments, he tossed the notebook and pen onto the passenger seat and sped home.

While the garage door clambered open, Gabriel turned the Mustang around and backed inside. He unlocked the trunk and went to a large white-washed cupboard. From a stash brought from New Orleans and left untouched since he'd begun writing romance, he picked up two cases of Jax beer and loaded them into the trunk. Leaving the trunk open he entered the house. Moving quickly through the large marble foyer, he skipped down the stairs hidden behind a breakfront loaded with Elle's cut crystal vase collection. Switching on the overhead lights, he began searching for a couple of empty boxes. After ten minutes, he simply dumped

the contents of three marked, respectively, SHOES 02, 03, and 04. None, of course, were his. In fact, nothing in the basement could be worn or claimed by him. As he looked around something struck him as odd. He couldn't pinpoint just what it was but couldn't wait for the thought to reveal itself.

He took a deep breath to redirect a spurt of anger, and carried the boxes upstairs to his study.

With a box positioned at one end, with one swipe of his arm, he cleared the surface of his desk. Papers, pens, books, and notebooks dropped unceremoniously into the carton, which he closed and set in the hall.

Rounding the desk, he turned the computer back on. For about thirty minutes he took care of banking and E-Trade chores, transferring money from certain accounts and closing others. From his documents file, he brought up *Love Moves II*.

With a sudden blast of insight he realized how stupid he'd been to even consider writing romance. He smiled to himself as he mentally deemed Antoinette de Beauharnais responsible for technologically kicking the naked Scottish backsides of Rosamunde and Ewan right off the monitor. Antoinette was good at that sort of thing.

Spending no time mourning the deaths of his vapid creations, he shut off the computer. On his hands and knees, he disconnected all the parts and placed the CPU, modem, and keyboard in a carton. From the walk-in closet he found the ViewSonic's box with its special Styrofoam inserts and carefully packed it. Making several trips, he stashed the computer components in the trunk of the Mustang.

Back upstairs, he stopped and regarded his office. The framed book jackets of his many mystery novels were long gone, packed and stored in his ex-wife's basement. At Elle's instance, he'd started *fresh*, not realizing at the time he was starting without a foundation, so perfectly symbolized in the glass-topped desk. He looked at the walls; the slightly brighter squares where the book jackets hung had almost blended completely into the blank space.

For the first time since his marriage he noted the other empty spaces, too, those that had been filled by wonderful photographs featuring former president Bill Clinton clutching one of Gabe's books, his other arm around Gabe's shoulders. They were, after all, both Georgetown alums and friends from college.

The hollow feeling he experienced nearly made him sick. If nothing else, Gabriel Hoya was a man able to focus on a mission. Writing books for so many years had given him that ability and he quickly dismissed any physical distress. Like a yogi, he inhaled deeply while raising his arms. He'd done this plenty of times while on the swim team in high school, exhaling while lowering his arms to his sides.

"Let's do it!" he declared.

He went to the double windows behind his desk. Elle had fitted them, like the others on the second floor, with delicate accordion blinds, the top half of which could be lowered by pulling one string and the bottom half raised by pulling another. At the moment they were much too complicated. He grabbed them and tore them away. Then he raised the lower part of the left window itself, noting as he did so how wonderfully wide it was. He stuck his head out of the window and enjoyed the heady, pheromonal scents of spring. And when was the last time he'd simply taken a breath of air out of his office window?

Ducking back inside, Gabriel pulled on the high back of his leather desk chair, the castors reluctant to move across the thick carpet. He remembered when this room served as a guest bedroom. Without even a protest, he'd allowed himself to transfer his work area from the airy, fluid space downstairs that opened up onto the deck to this restrictive cell so that Tyler wouldn't feel like a guest. Tyler of the one-night stand. Gabriel couldn't even recall what the boy looked like.

Again anger released energy into his muscles. Without thought of a hernia or any strain, unaware even of the annoying throb from the bump on his head, Gabriel managed to shift the inch-thick desktop on its twisted metal frame closer and closer to

the window. Pull one side, move around the desk, and push the other side. Repeat.

He vaguely recalled something Salome had said about the desk when she'd seen it. More than her words, he remembered her expression of horror. What was it she'd said? Well, no matter. At the time he'd quite liked the curved kidney shape and how it resembled an aquamarine pool. And how many hours had he contemplated his feet through the surface? Salome had been right. Writers' desks should never be transparent.

Now the desk was as close as he could get it to the window. He stood aside to catch his breath, nostalgic for his old walnut desk, now stored at Salome's, on which Antoinette and her gallery of rogues had romped and fought and loved and died in bloody glory.

Determination at the flood, blood boiling and every cell working toward the same goal, Gabe picked up one side of the weighty slab of glass and set it on the windowsill. Then he went around to the other side and pushed. His face reddened with the effort, which re-awakened the bump on his head. He did not care.

His cell phone rang. Sweat popped out on his forehead and he thought about his will. The cell phone vibrated in his pocket. Elle no doubt was on the other end. Or maybe one of the journalists he'd talked to at Honey's following up on the story. Christ, he thought, Sartre was right when he wrote, *"Hell is other people."*

Grimacing with the effort, Gabriel shifted the slab all the way. The thick glass caught the sun, momentarily blinding him just before the final heave.

Gabriel stuck his head out the window in time to see the great slab hit the far edge of the deck. The deck's hardwood slats took the weight, crunching but not shattering. After the moan and crack, the slab tipped over into the nine-foot deep end of the empty pool, where it crashed into a thousand shards.

Gabriel smiled as if he'd just heard the tinkle of Tibetan bells.

Tossing his duffel bag in the trunk, he slammed it down. Behind

the wheel of the black Mustang, he turned on the ignition, drove out of the garage, and plugged his favorite Delbert McClinton cassette into the tape player. "One of the Fortunate Few" un-spooled but as Gabriel began to sing along, the cell phone rang again. He braked midway down the drive. While the car idled, he removed the car phone, carried it back into the garage, and put it in his empty space. Taking the cell phone from his pocket, he left it on top of the car phone and closed the garage door on the echoing summons.

Gabriel drove out of the neighborhood feeling eighteen again and singing off-key:

"Too much stuff, there's just too much stuff,
It'll hang you up dealing with too much stuff."

Chapter Thirteen

"*JUDAH FREEMAN* to see April McGann," Jude announced into an intercom outside the gated estate off the Potomac Palisades. Though only a fifteen-minute drive from Malabar Close, they had just crossed Chain Bridge, having come from McLean where Salome purchased several new outfits and sleepwear at Chico's. No way was she going to present herself at Tres Soeurs mansion in jeans and a sweatshirt. Jude, too, had taken care to dress in a camel hair sports coat, an open-necked white dress shirt, gray wool slacks, and cordovan loafers.

As the gate swung open, Jude nodded at the guard in the gatehouse, then drove up the incline. They passed park-like lawns and gardens and pulled into a gravel drive. He parked behind a pristine black Mercedes so new that you could almost smell the leather interior. The gentle sound of water trickling down the three-tiered fountain centered in the courtyard between the mansion's two wings lent a relaxing, tranquil air—at least until the front door was opened.

The woman who answered the bell pushed aside a wisp of gray hair sticking to her damp, reddened cheek. Though sturdy enough, she looked careworn and well past retirement age. But their attention was drawn to a different person, a tall woman somewhat familiar to Salome. They followed her gaze as she stared up at a chandelier, a new addition since Salome had been here a year ago, something an ignorant interior decorator might

try to pass off as "magnificent." Constructed of myriad spikes blown and fashioned to sharp points from a central globe at least eight feet in diameter, the lethal fixture brought to mind a mace wielded by a malevolent Olympian deity. The tall woman was regarding it with a beatific expression as if she were the proud creator of this mass of destructive energy. Its presence, especially here at the entrance, did not bode well for April McGann.

The clatter of wineglasses broke the brief spell. The elderly woman closed the door. A young man in white shirt and black trousers, a black bowtie unfastened at his neck, pushed a trolley laden with champagne flutes into the wide foyer, heading for the cavernous conservatory to their right. At the same time, someone began banging Elton John's "Crocodile Rock" on a piano. A fine rendition, but poorly received by the tall woman, who turned and poked her head around the corner.

"No bloody rock and roll! Cole Porter or Gershwin."

Immediately they heard "Ain't Misbehavin'."

Jude laughed, drawing the woman's attention.

"And who might you be?" she demanded.

"We might be Othello and Desdemona, or even," and now Jude lowered his voice, "Amos and Andy." Obviously, he did not know who he was talking to, probably assuming her to be the party planner.

The woman took a trip across the marble floor, the sharp sound of her heels complementing her now sour expression.

"We did not hire comedians for tonight's fund-raiser. I don't know how you got past the gate but you're at the wrong party."

Now Salome recognized June McGann, having first seen her at April's birthday party last year.

Before Jude could comment, the older woman interceded, "They're expected."

"Oh?" She gave Salome an odd look, as if Salome's was a familiar face but not easily placed.

Without explanation, the older woman said to Salome and Jude, "Come with me, please."

In the brief instant the old woman's eyes met Salome's, they seemed to express agreement with Salome's assessment of the crystal monstrosity.

Salome and Jude followed her to the left and up the wide, red carpeted staircase, spikes of poison arrows seeming to shoot at them from the chandelier or the tall woman, or both.

Salome touched the mirror in her pocket, the one Fiona had allowed her to borrow from its place on the outside of her bathroom door. The mirror would deflect the negative energy Salome expected to be shot at her, and by proximity, at Jude, while they were in the Tres Soeurs mansion.

Salome remembered the route. At the top of the stairs, the older woman moved south, not toward April's bedroom, which Salome knew was in the wealth gua of the mansion, but toward "knowledge and spirituality."

Before entering the room at the end of the long hallway, the woman stopped. Her demeanor changed. She checked her hair, straightened her gray dress, and flexed her hands.

Once she had completed what Salome referred to as "consolidating body ch'i," the tiny automatic actions that prepare one for entering a room, Salome and Jude followed her into a large sitting room with several conversational groupings of flowery upholstered couches and chairs. French doors opened onto a south-facing balcony, affording a breathtaking view of the currently placid Potomac River and the densely wooded hills of northern Virginia beyond.

April sauntered into the room from the bedroom, well to the north and past the tall screens separating the sleeping quarters from this area and the table, which Salome remembered for good reason, showcasing a collection of paperweights. Neither Salome nor Jude could take their eyes off her, her shapely body covered in what appeared to be layers of gold leaf. Her blond hair was pulled back from her face in a simple chignon.

"Detective Freeman," she said graciously. Retracting her hand, she regarded Salome less warmly.

"My partner, Salome Waterhouse."

"Partner? I remember you as Grace Wu's friend," she said, and moved toward a furniture grouping in front of the French doors. Jude quickly claimed a corner chair in the command position, Salome noted, affording him a view of the entire room.

"Strange you'd be partnered with a Feng Shui consultant."

"Ms. Waterhouse is a trained observer, one who sees things that others overlook. Besides, she has extensive experience with criminal investigations."

This time, April's eyes momentarily widened with what Salome recognized as fear. Then she looked away and rigidly avoided eye contact.

"Give Larsen your drink order. Anything you want."

Jude requested a beer, Salome water.

Seating herself on a loveseat diagonally across from Jude, April said over her shoulder, "Scotch for me. You know how I like it."

Larsen hurried from the room. April leaned forward and opened a silver box of cigarettes, extending it first toward Jude, then perfunctorily toward Salome. Both declined, but Jude got up to light April's cigarette with the matching silver lighter. April cupped his hand and puffed. She sat back and exhaled a thin stream of smoke.

"Poor Larsen," she said conversationally. "She hates working for my sister—you met June downstairs? She's so proprietary about that chandelier you'd think she blew the glass herself. My birthday present and a week early. But she wanted it hung for tonight's party."

"The fund-raiser," Jude remarked.

"Republican fund-raiser. June prefers to use Tres Soeurs for these dos. I don't mind opening the doors to her set on occasion. A party's a party but her taste—when was the last time you had *fun* with a *Republican*? Still, I look forward to meeting her new love interest, some musty old British lord." She shrugged, her gold dress shimmering.

For a brief moment, Salome felt pity for June. She looked at

Jude. He seemed to be enthralled with April's nervous patter but she knew that as well as computing each morsel of information, he was waiting for the opportunity to pounce.

"Larsen wants to come back to Tres Soeurs but arthritis, you know. I need an energetic housekeeper. Devotion does count for something, though."

"And last year, you fired the staff at the behest of your former fiancé, Duncan Mah."

Salome saw disparate emotions battle just beneath the surface of April's well-maintained face, a certain respect for the former homicide detective finally winning.

"Are you showing off, Detective Freeman? Letting me know you have spies in the domestic service sector?"

"Contacts."

"Even so, they're not *that* well informed. Larsen, a fixture in this house for years, just couldn't keep up. Duncan had nothing to do with her leaving."

"Fine. As I told you on the phone, we believe Mah is responsible for a fire in Malabar Close last night."

"Did anyone see him there?" she said, her tone smug.

"The puppet master stays out of sight," Jude replied.

"And speculation is such a silly pastime—but I suppose you have to fill in the blanks when you have no hard evidence."

"Are you still seeing Mah?"

At that moment Larsen entered, carrying a wide silver tray containing their drinks. April rose from her seat and moved to the French doors. Salome offered to take the tray. Larsen, looking pained but determined, frowned and shook her head slightly. She carefully set the tray on the coffee table, then took a deep breath. Before she could pour his beer from bottle to frosty glass, Jude grabbed both and nodded a thanks. Larsen handed Salome a tall glass of water over ice with a white linen napkin. Carefully placing a napkin beneath a highball glass containing amber liquid over shaved ice, she took the beverage to April.

April moved back to her chair and stubbed out the cigarette.

"Larsen, you forgot canapés."

"We've eaten," Salome interjected, hardly believing that April would send the older woman on another trip through the house and back.

"Bring a plate."

"Certainly, Ms. April."

Salome told herself not to get caught up in April McGann's manipulation of Larsen. Though revealing, it wasn't the reason they were here. At the same time, Larsen might welcome the opportunity to prove herself to April McGann.

"Cheers," April said flatly and raised her glass.

"Are you still—"

April interrupted. "Seeing Duncan? Certainly not."

While her voice carried conviction, her eyes wandered up and away, leading Salome to believe she was lying.

"When was the last time you were together?"

"My birthday party last year. April, of course." Abruptly, she turned in her chair. "Larsen!"

Larsen stopped just inside the doorway.

"Bring the necklace."

When Larsen left the room, April looked directly at Salome and spat, "You humiliated Duncan! Imagine, accusing him of stealing the necklace when he was saving it from theft! You caused him to lose face. Being Asian yourself, I think you'd be well aware of the significance of face."

Salome had no doubt April was now telling the truth—truth as she saw it, colored as it was by denial—and suddenly realized that April blamed her for the collapse of her engagement to Duncan Mah.

April paused to take a swallow of scotch, the drink restoring a more civil tone as she stated with pride, "Duncan's a dealer in fine Chinese art."

Without missing a beat, Salome retorted, "So how do you explain the low- to mid-range merchandise in his former shop on Wisconsin Avenue?"

"So? The shop catered to the tourist trade. High-end pieces were for an exclusive clientele."

"Wisconsin Avenue isn't exactly Chinatown, Ms. McGann," Jude pointed out. "How many tourists come to Georgetown to buy inexpensive Laughing Buddhas? The shop was a front for his illegal interests."

"There is no proof he was ever involved in anything illegal! All successful business people have to put up with accusations by jealous competitors."

Again, as if on cue, Larsen entered just at the right time, carrying a large black velvet box, which she gave to April. April opened the box to reveal a necklace on a bed of sapphire blue satin.

"The Tres Soeurs necklace," April thrust the box at Salome. "Here, give it a close look. It's why you're here, isn't it? To get a really close look at something extraordinary, something you'll never have."

Beginning to understand the extent of April's denial, Salome ignored the comment, and examined the piece for the first time. She'd only caught a glimpse of it the previous year, when she herself had prevented it from being stolen right down the hall in April's bedroom. On a chain of square-cut diamonds were an emerald, a ruby, and a diamond, each about forty carats. In addition, a part she had not seen before was a pendant featuring three images of the Egyptian goddess Isis in profile: one encrusted with emeralds, another with rubies, and the third adorned with sapphires.

"Is the pendant new?"

"It had gone missing until last summer—but that's another story.

"My great-grandfather had the necklace made for my grandmother and her two sisters. The three women were members of the Eastern Star, the women's arm of the Masons. My mother and her two sisters inherited the necklace and then it was passed down to our generation.

"June, May, and I have possession of it for three years each. Another sister can borrow it for a special occasion, say a White House function. May doesn't want anything to do with it; she says it just brings bad luck. After I wear it on my birthday next week, June will take it. Though in truth it looks silly on her."

Salome extended the necklace to Jude. Without comment, he got up and gave it to April.

"You don't seem very impressed, Detective." Then she said, "Would you please put it on me?"

Jude positioned himself behind April and taking both ends of the necklace in his hands laid the weight of it on her chest. While securing the clasp he said, "When Harry Winston acquired the Hope Diamond, he showed great wisdom in donating it to the Smithsonian. Millions of visitors—myself included—can admire the genius behind its creation. When privately owned, such extraordinary pieces bring out the worst in human nature."

Jude stepped back. April touched the jewels at her neck and stood up facing him. If she expected to dazzle him to numbness with both her beauty and jewels, she did not succeed.

"What's your interest in Black Friar's Books?"

She hesitated a moment too long, her frown unconvincing.

"On Wisconsin Avenue," Jude prompted. "You know the store. You've been seen going in."

"I consented to this interview to put an end to the speculation that I am still seeing Duncan. Need I remind you that you are no longer a well-regarded Metropolitan policeman, but simply another civilian that I do not have to speak to."

"And as I told you, you can talk to me and my partner—in confidence—or a Second District cop investigating the arson at Malabar Close who would think nothing about talking to the press and reopening the humiliating episode when Duncan Mah left you at the altar in Bermuda."

April moved to the French doors leading to the balcony, a clear sign that they were no longer welcome.

"Just so you know," Jude said, "we'll be talking to your sisters."

"Fine. Good luck with June…and how timely that she's right here. Though she'll undoubtedly tell you to go to hell. May, well, she's so far out of the loop she probably doesn't remember who she's related to. But go ahead. My sisters are not going to lead you to Duncan."

"The man's a sociopath," Salome said. "Why do you protect him?"

"Larsen, show them out."

Once they reached the door of the room, April called, "Detective Freeman? A word, if you don't mind."

"This house must be very familiar to you," Salome said when she and Larsen had left the sitting room and were moving toward the staircase.

"Lord, yes. Spent most of my life here."

"You must have met Duncan Mah."

Larsen halted at the top of the stairs and looked around, though the landing was free of people. She whispered in a conspiratorial manner, "He's a skunk! After Ms. April's money. But will she hear a word against him? Absolutely not."

"Have you seen him lately? Has April mentioned him?"

"Except for parties, I work at Ms. June's house now."

"We believe he was responsible for a fire at my house last night."

Salome saw fear in the older woman's face. Larsen started down the stairs. Salome hurried to keep up.

"Please, anything you've seen or heard."

At the bottom of the stairs, Larsen accelerated her pace. Moving ahead of Salome, she turned and motioned for Salome to hurry. Salome followed her outside to the fountain where the splashing water covered Larsen's words.

"He's here: I feel him like an evil wind."

"You mean here? At Tres Soeurs?"

From the balcony, April called down. "What are you doing, Larsen?"

"Just making certain they leave all right and proper, Ms. April."

"I'll see to that. Go fetch me a drink."

"Certainly, Ms. April."

In a low voice, Salome said. "Call J. Freeman Investigations any time you want to talk."

Judah entered the courtyard and he and Salome got in his car and drove off, April's watchful eyes burning into the back of their necks.

"Well?" Salome said. "What did she want?"

"Invited me to her birthday party next weekend."

Salome told him what Larsen said about Duncan Mah being "here."

"What the hell's going on with these people?" Jude remarked. "June has April followed for two weeks. April says she hasn't seen Mah in a year but the housekeeper says he's around." He took a breath, then said, "What's your take?"

"That chandelier does not bode well for April McGann."

"Given enough money, people will buy anything."

"Jude, it's a lethal weapon. Those spikes shoot poison arrows in every direction."

Apparently he wasn't listening.

"So, are you going to her birthday party?"

"Wouldn't miss it for the world."

He checked his watch. "Got time to visit Black Friar's?"

"Sure."

The CLOSED sign had the added feature of a clockface with a single hand pointing at 11 o'clock and *Sunday* printed at the bottom. It hung in front of the curtain inside the door's window at Black Friar's Books. They walked back up the stairs and to the town house. No one answered the bell. They strode around back to the alley. Jude knocked but again, no one answered the summons. Jude tried the knob but the door was locked; then he pressed the buzzer. After waiting a few more minutes, they returned to Jude's car.

"Instead of your driving me all the way back to Dupont Circle, why don't I just get a cab?"

"Because I'd rather give you a ride. Besides, I want to take a look around the neighborhood, make sure everything's cool."

Having plenty of time before dinner, Salome decided to soak in the Japanese bath near her room. Living in a constant state of unease was something she was not used to. She had the feeling she would be making use of the bath to relax on a regular basis until she could move back to her house.

Observing the proper order, she showered first, then sank to her neck in the round wooden tub's hot, steamy water. For half an hour she barely moved, allowing the heat and water to work their magic.

Back in her room, she closed the curtains and switched on the bedside lamp. She grabbed her handbag, remembering she hadn't turned the cell phone back on after making dinner plans with Germaine. There was one message. She recognized the number as that of her mentor, Grace Wu. Eagerly, she punched in the numbers. It was three hours earlier in San Diego where Madame Wu had retired.

"Hello, Grace," Salome said.

"Salome, dear, so kind of you to return my call."

"What can I do for you?"

"Time to spruce up your fame gua!"

"Oh?"

"Salome, the video! It should be in stores any day now. My nephew tells me they worked day and night to fill the orders."

Last October, Salome had finished work on a Feng Shui instructional video shot primarily at Madame Wu's home in San Diego. Salome had "acted" the part of a Feng Shui practitioner, the tape directed and produced by Madame Wu's nephew, Charles Wang, who turned out to be a perfectionist of the highest order.

"I'm surprised he finished!"

"He had some very insistent investors," Grace said with a sharp laugh. She had been in the opening scene, a short segment,

to introduce Feng Shui and Salome, and finally threatened to quit if Charles didn't stop calling for take after take after take.

Salome told her about the lovely accommodations at the Asian-American Women's Association, giving her reason for staying as renovations at her town house, which of course was true.

"Remember Duncan Mah?" Salome said, hoping she sounded casual.

"Why?"

"His name has come up since I returned to the District a couple days ago and I was just wondering if you'd heard anything about him."

There was a pause on the line and Salome wondered if they'd lost the connection.

"Grace?"

"Oh yes, I'm here. Many people work for him, Salome. Good people who will do bad things to pay off their debts. Smart people stay away from him. Like you, I hope."

"Of course, Grace."

"Now, concentrate on the fame gua."

After hanging up, Salome began combing out her hair. Deciding on a TV news broadcast for company, she moved over to the desk to plug in the hair dryer and was just about to switch it on when she heard a familiar voice.

"...had come over to check on her. She works—worked for us...."

Salome exchanged the dryer for the remote and increased the volume just as the tape cut from a headshot of Gabe to a shot of the brick house, an ambulance in the driveway, and Gabe, shot from behind so all the world could see the flesh of his bare backside through the worn jeans. She wondered how many viewers would remember MURDER BY THE BOOK, HOUSTON, TEXAS printed on the back of his T-shirt. Or for that matter, the apparent suicide of one Honey Lee. The reporter seemed more interested in the irony of a best-selling mystery author finding a corpse, plus the titillating detail that such a wealthy and successful

person dressed like a slob when he thought no one was looking.

Salome sat in stupefied silence until the station cut to a commercial. She wondered if Elle had seen the broadcast, if she and Gabe were watching the news together. Though she probably liked having her husband on television, Salome doubted she'd be pleased by the way he was dressed.

She now wished she'd called him earlier, even last night. For the next few days he'd probably be inundated with requests for interviews. He needed to know that she was having the various things of his in the basement taken to a storage facility. At least she could leave a message.

After two rings, the message tape clicked on. "Hi, Gabe, this is Salome. Give me a call on my cell phone." She left the number, then dressed for dinner with Germaine.

Chapter Fourteen

SALOME ENTERED the small café across the street from Black Friar's Books, the tiny eatery chosen by Germaine. She had dressed in one of her new casual outfits, attire suitable for the inexpensive restaurant. There were about a dozen tables, all but a couple taken. Germaine was not among the customers. Salome went to the long counter that ran along the back of the room. A blackboard menu listed salads, soups, sandwiches, and desserts. Salome ordered a cup of tea. When Germaine arrived she'd decide what to eat.

She had just paid for the beverage when her cell phone rang.

"Yes?" she answered, and slipped into a chair at the nearest empty table.

"See the couple sitting at the table in front?" Salome instantly recognized Germaine's voice and heard traffic in the background.

"Yes."

"The woman's June McGann. Did she see you?"

"I didn't really pay any attention."

Germaine gave her the name of a bar up the street, asked her to meet her there, and rang off.

Salome took her mug to a bin provided for patrons' dirty dishes and moved toward the door. Swathed in shiny black sable, June McGann sat by the window, engrossed in conversation with her male companion. Neither noticed Salome leave.

Moments later, Salome joined Germaine at a tall, round table in the bar beside one of two windows fronting the busy street,

at an angle now to Black Friar's. From this new position they could also see the entrance to the alley that ran behind the bookstore.

"Freaked me out when I saw her," Germaine said, her voice taking on a high pitch. "I'd just parked my car in a lot off Wisconsin and was walking toward the café when she got out of a limo and went inside. I backtracked and went around the block so I was just across from the alley when I saw you go in. Looks like she had the same idea I did."

"She's supposed to be hosting a fund-raiser at Tres Soeurs. April plans to attend." Salome filled her in about the earlier interview at the mansion.

"Damn, I thought we might get lucky and catch April going into the bookstore. Oh well, it was a long shot."

The waitress came and took their orders. When she left, Germaine leaned forward. "Look, I gave the couple sitting at this table a twenty to move. Would you mind buying my drink?"

"No problem."

"I don't suppose Jude would consider a fashionable martini as a legitimate expense."

"When the money's there, he's generous. During the dry spells, he's pickier."

"But I've got to tell you what happened after you and Jude left this morning! First, I had the front door replaced. The original door was right there in the basement storage area. They'd replaced it because the previous tenant painted it the most beautiful shade of red. They put the other door up, believing they wouldn't be able to rent the apartment unless it had a uniformly boring door! Then, the maintenance guy and I carted that horrid mantel down to my storage area. Well, I hadn't been back in my apartment thirty minutes when the phone rang. It was my mother. She's getting married to a wealthy retiree and I have permission to dispose of the furniture as I please! She even gave me the name of a woman in Fairfax who sells upscale secondhand furniture and antiques. I called her and she's coming tomorrow.

"I'm still amazed," Germaine said shaking her head. "What can I say? You're awesome."

"Feng Shui is awesome."

Germaine smiled broadly, her eyes twinkling. Then her expression changed. "Look!" She nodded toward the bookstore. Two young men trotted down the stairs. "If it's closed, they'll be back up."

"Jude and I stopped by late this afternoon. The sign indicated it wouldn't open again until tomorrow at eleven."

After a few seconds, the two young men returned to street level and stood talking for a moment.

Germaine looked disappointed. "I guess they really were interested in the bookstore."

"Wait a minute," Salome said.

Germaine and Salome watched as the youths turned down the street and entered the alley. By the time the waitress brought their drinks and Salome handed over her credit card, the youths still had not reappeared.

"Hmm," Germaine intoned and took a sip of her "dirty martini." "Doesn't mean they were admitted through the back entrance. If we hung out across the street we could see the alley."

"June would see us."

Just then, a middle-aged man, dressed like the stereotypical college professor in cords and tweed jacket fitted with elbow patches, strode purposefully into the alley. The waitress reappeared and Salome signed the receipt and put her credit card in her wallet.

Over the next fifteen minutes, the alley was positively bustling, as a total of five more men entered but didn't come out. Then an ordinary sedan pulled off Wisconsin and braked at the entrance to the alley. Immediately, two men stepped up to the car from the alley side. The shorter of the pair, a Chinese man wearing a suit too small for his stout body, opened the back door. The second man, looking elegant with a dark overcoat hanging off his broad shoulders, ducked down and climbed into the backseat.

The stubby man closed the door and hurried around the back and got in beside the driver. Immediately, the sedan sped off down the street.

"Was that him?" Germaine hissed as she squeezed Salome's forearm.

Even from this distance and seeing his handsome face for just a matter of seconds, Salome recognized Duncan Mah. She stared at the now-unblocked entrance to the alley, skin tingling with a mixture of fear and excitement.

"Salome!"

"Yes, that was Duncan Mah. Damn! Did you notice the license plate number?"

"No. Did you?"

Salome shook her head. "I'd better call Jude."

As Salome grabbed her handbag, the man she had seen with June stepped out of the café. He moved up the street and stood right in front of Salome and Germaine. With his back to them, he flicked open a cell phone. The music and laughter in the bar prevented them from hearing what he said. No matter, he quickly concluded the conversation and put the phone in his jacket pocket.

Salome reached into her bag and grabbed her own phone. A limousine passed and they could see June McGann in the back, her window rolled down, nod at the man standing on the street. Germaine cursed and spun around in her seat.

"Did she see us?" Germaine spoke facing the interior of the bar.

"I don't think so. You can turn around, she's gone."

She had just punched in the first three numbers of Judah's cell when a patrol car shot down Wisconsin, then turned the corner and stopped, blocking the alley. Salome disconnected and turned her attention to the street. Another patrol car followed and jerked to a stop at the front of Black Friar's. Two cops ran up the steps to the front door of the town house, while others went into the alley.

The man who'd been with June dashed across the street. Salome and Germaine figured he must be a cop when he joined the others at the town house. Several of the bar customers went outside and a crowd formed as passersby stopped to watch. Their ringside seat now blocked, Salome and Germaine moved outside.

It was over quickly. Various people in the crowd speculated about the nature of the raid as all the males Salome and Germaine had seen were hustled into the patrol cars, their hands cuffed behind their backs. Most of the people around them believed they'd just witnessed a drug bust.

Salome and Germaine walked down the block back to the café. Salome ordered a salad. Germaine took her time, appearing more interested in the attractive young man behind the counter than the offerings on the blackboard. Salome gave Germaine cash with which to pay for their meal, found a table, and called Jude.

On the second ring, he answered, his tone hostile. "Freeman."

"It's Salome. You okay?"

His voice softened. "Divvying up stuff with Cookie. No big deal. What's up?"

She told him about the raid on Black Friar's and seeing Duncan Mah.

Jude cursed, an all-purpose word that probably covered his current activities along with his reaction to Duncan Mah's avoiding the law by a hair. "I'm outta here."

"You headed to the Second District station?"

"Roger that."

"Call me—" But Jude had already disconnected.

Finally Germaine arrived, carrying a tray with their food and Salome's change.

"Do you think Duncan Mah was tipped off?"

"Either that or he happened to be leaving at just the right time, which makes him one hell of a lucky guy. It'll be interesting to find out who owns the property."

Germaine smiled coyly. She was facing the counter, and

throughout the meal was to present a catalogue of pleasant expressions that had nothing to do with the point of their conversation, something Salome was to find increasingly annoying.

Salome forked baby greens and blue cheese crumbles into her mouth as Germaine said, "Yes, but, what is June's involvement? Did she instigate the raid or tip off Mah?"

For an instant, Germaine's gaze slid over to the counter. She smiled, then answered her own question. "Probably the former. That would account for her presence. And not for a minute do I believe she just happened to be here and in a ringside seat. If I were her, I'd want to make sure what I put into motion was carried out."

"But she could not have seen Mah leave, not from where she was sitting."

Again, Germaine smiled.

"On the news tonight—" Salome began.

"Right! Right! I saw it. Your ex, well—how embarrassing for you." Germaine sipped some of her chicken soup.

"I was thinking of the reason he was there. He said the suicide victim had worked for him, a Chinese woman who was an 'organizer.' You mentioned this morning that June had an organizer."

"Wow. I hadn't even thought of that. And of how many organizers in this area are Chinese."

"Did June mention her name?"

"What stuck was the comment about her being 'out of my league.'" Her momentary gloom swung back to coyness when she glanced at the counter again. "Tell me something."

"What?" Salome asked.

"Do you like my hair?"

Salome blinked, speechless for the moment.

"What I mean is, do you think it's flattering?"

"Oh, well, certainly. Quite pixyish."

"As in youthful?"

Salome nodded.

Germaine pushed her soup bowl to the side. "I think I'll have dessert, hang out here for a while; maybe catch some news about the raid."

Salome got the message; after all, Germaine had just removed a blockage in her relationships gua.

After returning to AAWA, Salome changed into the comfortable new thigh-length nightshirt and waited for Jude's call. She was just in time to catch the news but there was no further mention of the suicide. Honey Lee's moment of fame had come and gone.

She shut off the television and closed the armoire's doors, reminded of why television news always left her feeling depressed. Corporate media had become a giant roving eye, seeking death, as if like a shark, it, too, would die if it didn't stay in motion. The dead were helpless and their lives reduced to a sound bite.

"Can't sleep?" The desk clerk, a young Asian woman, looked up from a textbook, a green Hi-Liter in her hand.

"Actually, I thought I'd have a look at the library, if I may," Salome said. She now wore jeans and sweatshirt.

"Sure, no problem. It's open. There's wood if you want a fire, but be sure to put the screen back when you leave. If you want a cup of tea or something, I can open the kitchen for you."

"That's very kind."

"Hey, nothing to do but study."

"You're a student?"

"Asian studies at American University." She smiled and dimples appeared on either side of her wide mouth. She directed Salome around the corner, past the lounge, and told her where to find the light switch.

Large double doors opened onto the library. Salome switched on the table lamp just inside the door, beside which was a bowl filled with business cards. To the right were two desks, perpendicular to the wall and facing the door, with computers hooked up to

the latest thin plasma monitors that freed up desk space. Laminated cards informed of the steps to take for Internet access.

Bookcases rose from floor to ceiling, all high shelving accessible by ladders on runners. Additional shelving rose on either side of the fireplace, between and flanking two tall, narrow windows. Supple leather chairs, wrinkled with age, were provided here and there, the only grouping with a coffee table positioned in front of the fireplace. A long table in the center of the room held stacks of newspapers.

Salome wandered around the room inhaling the dry scent of hard-bound books and ageless knowledge: philosophy, travel, history (China well represented here), politics, art, science, and not surprisingly, given that this house once belonged to Madame Wu, hundreds of volumes on Feng Shui. All but a few of these were in trade paperback, representing every school from Black Hat Sect, Salome's personal choice, to Compass School, and written by Chinese, Australian, New Zealand, Hispanic, British, German, Italian, and American authors. She thought of her own book, the rudiments of which had been turned to ash along with the living room couch.

Having reached the table of newspapers, she scanned the neatly stacked offerings, the latest editions on top: Hong Kong dailies in English, Cantonese, and Mandarin; the *International Herald Tribune,* the *Sydney Morning Herald;* British papers—*The Times* and *The Guardian*—and American papers, including the local *Washington Post* and *Washington Times,* and one she wasn't familiar with, *All Asian-American Gazette.* Thumbing through the latter, she noticed publishing information: the publisher one Howard Chen, in Arlington, Virginia, since 1998.

Finding paper and pen in one of the desk drawers, she wrote down the name, address, and phone number. Possibly this man, Howard Chen, could at the very least provide a lead into Duncan Mah's hidden world of illegal Chinese immigrants, at best open the road to the elusive Snakehead's whereabouts.

She moved along the shelves, specifically looking for books on triads, the Chinese criminal societies. Her search unrewarded, she went to the front desk.

"Yes?" the clerk asked.

"I couldn't find a card catalogue."

"That's because there isn't one. What are you looking for?"

"Books on the triads."

The clerk shook her head. "Won't find anything like that here. Have you heard of Feng Shui?"

"Oh yes."

"There's a great selection of Feng Shui books. Why not read one of them? You never know, it just might change your life."

Chapter Fifteen

JIM SELSOR and two other men were already at work, a large refuse container nearby, when Salome arrived a little after eight A.M. Sunday morning. Jim had parked his new pickup in front of Fiona's house behind a white-paneled moving van. He introduced the two GW students there to haul away the furniture. The bright-eyed boys positively beamed when she wrote out the check for their services, which included a deposit and month's rental on a storage unit in Arlington.

What had once seemed like a lot, when finally fitted into the van, furniture and all the odds and ends packed in sturdy, neatly labeled cardboard cartons, seemed a small representation of her single life in Washington. Even so, the significance of this change in her life loomed large. As she watched the van disappear around the corner, it tugged at her heart. She might have succumbed to tears had not Judah driven into the Close just seconds later.

"Looks like you need some lunch," he said. Regarding her forlorn expression, he amended the observation. "Maybe a hug first."

For a long moment he held her to his chest. She sucked in a sob, then realized that he had been through a similar experience last night. Determining who owned what after a thirty-year marriage enlivened by three children had to be heartbreaking. Compared to his trauma, she was simply sending her stuff on vacation.

She pulled away and smiled. "Food sounds good. But information, better. Why didn't you call me back last night?"

"Didn't get out of the station until two." He started toward his car. "Come on, let's grab a bite."

"What about Fiona?"

"She flew to New York last night."

That explained why Salome's neighbor hadn't appeared during the past few hours.

Salome said good-bye to Jim Selsor, then hurried after Jude. "Don't tell me there's trouble on that front."

Jude shook his head. "She needed to go and I added insistence. In fact, I drove her to the airport before going to the station."

While Salome fastened her seat belt Jude said, "Look, Mei, I'd rather not talk about my relationship with Fiona. I mean, you and I have been friends for a long time—and I know it's weird that she's your neighbor but she and I started out, too, as friends. Not off the bat but we talked every once in a while when I was house-sitting for you. God, when was it? Winter before last?"

"Does Cookie know?"

Jude snorted but smiled. "Hey, you don't spend thirty years with someone and not know something's going on. So, yeah, I think she knows I'm not sitting in my apartment pining for her. She just doesn't know who."

As they drove off, Salome looked back, suddenly realizing that, maybe for the first time in two hundred years, the fine hous-es of Malabar Close were each without tenants: Fiona to New York City, Ruby in Fredericksburg, the manor house and "the Richmans' place" empty—and of course, her own town house now hollowed out. Extraordinary changes had occurred in the year since Duncan Mah had drawn negative energy to the place. Though temporary, and beginning with the destruction of the old rose garden fronting the manor house, Mah's influence had been, to Salome's way of thinking, profoundly unsettling.

"Duncan Mah has given me an appetite for Chinese food. Sound good to you?"

"Sure." Salome's lips formed a pleasant enough smile but at the moment she doubted she could stomach more than egg drop soup.

Given the light traffic, coupled with Judah's incredible knowl-
edge of the District's streets, in no time they passed beneath the
hugely impressive Chinese ceremonial arch, which spanned four
lanes at the Gallery Place subway stop. Unfortunately, the arch
itself was the best thing about the District's puny Chinatown, a
reminder that all was not as it seemed in Washington, D.C. But
then, monuments and colorful, elaborately carved arches could
not be counted as more than gateways to an ideal rather than a
reality.

How telling that within five minutes, Jude had parked, they'd
chosen the restaurant, and were seated with menus. In San Fran-
cisco's Chinatown they could have spent considerably more time
selecting a place to eat, distracted in the process by a plethora of
shops, meandering streets, and an excess of people. Still, it was a
perfect spring afternoon, the air warm and soft.

"Egg drop soup." Salome handed the huge red menu to the
waitress.

Jude ordered three dishes.

When the waitress left, Salome sipped her small cup of jas-
mine tea. "Emotional distress never hurts your appetite."

"*To serve and protect* requires fuel."

"There was a teaser on the late news about the gambling bust
at Black Friar's," Salome said. "The cops were there and gone in
just a matter of minutes. No time for the press to get over there."

Jude sat back in his chair, placing his hands on the utensils,
then straightening his half of the white tablecloth.

"Seems pretty stupid, having an illegal gambling operation in
the same place an illegal gambling operation had been busted."

"Come on, Mei. No one ever accused criminals of being rocket
scientists. The way I see it, they figured lightning wouldn't strike
twice. But there's more to it than gambling. One of the kids, a
math major at Georgetown, bought a credit card from a man
fitting Duncan Mah's description. Apparently, Mah dropped in
with credit cards, Social Security numbers, and identities for

sale—two thousand and up a pop. The kid and his girlfriend were planning a European vacation at the expense of none other than June McGann."

"You're joking!"

"I kid you not."

"So who owns the place?"

"Property's owned by some corporation and is managed by a firm in Alexandria. Jack Friar, Blackie's little brother, leases space for the bookstore but he doesn't live upstairs. From what I heard last night, people come in to gamble a couple nights a week. No one seems to know what the place is used for the rest of the time. My guess: April and Mah's love nest. And Jack Friar's unavailable. Seems he left on an extended vacation."

When the steaming plates of food were set down, Jude's attention shifted to the shrimp fried rice, garlic chicken, and succulent beef strips stir-fried with a variety of vegetables.

The sight of the food plus the delightful aromas kick-started Salome's appetite, and by the time they finished, two more plates had been ordered.

"Wherever you want to go," Jude said, sated by lunch and moving toward his car, stomach leading.

"Drop me off at the Tidal Basin."

"There'll be crowds, babe. It's Sunday."

"I don't care. I always get a lift seeing the cherry blossoms and I might not get another chance before they're gone. Besides, I need to walk off the meal."

Approximately 3,700 ornamental cherry trees encircle the Tidal Basin, and are cared for by the National Capital Parks Central crew. The mayor of Tokyo had gifted the capital with thousands of trees in 1912. During the short blooming period, the Tidal Basin is transformed into a pink wonderland that draws crowds from all over.

For Salome, an amble along the Basin amid the flowering trees

was a special time to honor her Japanese ancestors. This day though, her "walking meditation" was less than tranquil as she dodged running, energetic children and adults who would suddenly stop in their tracks and gaze up at the trees or across the water toward the Mall or the nearby Jefferson and Roosevelt Memorials.

Even so, she enjoyed the velvety feel of the breeze and the pink haze of petals floating in the air, the sensation one of passing through a gentle spring shower of blossoms.

Completing the circuit, she crossed over Independence Avenue, and at a brisk pace, passed the Korean War Memorial with its ranks of shell-shocked soldiers: to her way of thinking, a vivid anti-war monument.

Further on, she paused momentarily to gaze up at Lincoln regarding the world with an expression of serene unhappiness. Surreptitiously, she glanced behind her. There were plenty of tourists snapping pictures from cameras that hid their faces. Moving on, she strode down the narrow walkway of the Vietnam Memorial, and as always, finding her own image reflected in the polished black granite a reminder that she had been a part of that war as well; one of the lucky ones who had not lost a loved one, nor herself.

The crowds thinned as she approached Constitution Avenue. She crossed the wide avenue and hurried toward her favorite memorial, located between Twenty-second and Twenty-first streets and hidden behind tall hedges.

A moment later she found herself alone with Albert Einstein, all four tons of him seated casually on a white granite bench, a kind, melancholy expression on his face, and a star map and marble horoscope at his feet cast for noon, April 22, 1979—the date of the statue's dedication.

She climbed up on his right thigh, across from the paper he held covered in mathematical arcana. "Mr. Ch'i," she called him, for enlightening the world on the nature of energy. The

entire piece, created by American sculptor Robert Berks, was an inspiration.

This being Sunday, she probably wouldn't have the place to herself for long. Soon enough there'd be children climbing all over the statue.

Since taking up Feng Shui, she had felt a stronger connection to this place than when she had first begun visiting with her ex-husband. With knowledge of the Bagua as her guide, she now knew of the memorial's auspicious placement in the knowledge and spirituality gua, in the southwest corner of the block where the National Academy of Sciences is located. And Einstein studied energy. So did Salome, energy being the basis of Feng Shui.

Her body relaxed. She relinquished everything, even fear and a suspicion that she was being followed. But vulnerability was necessary in order to achieve her intention.

Indeed, for perhaps a moment or a lifetime, Salome entered a Zen-like place of nothingness, which was, in fact, the stream of universal life energy. Human constraints did not exist. She ebbed and flowed in light.

A boy and girl charged into the memorial, squealing with delight. Their parents came after, smiled at Salome, then settled in to watch their offspring climb over the lushly sculpted form, maybe hoping Einstein's genius might rub off on their kids.

Shortly after, Salome left and caught a cab back to AAWA. The clerk handed her a phone message from Jude. He wanted her to come to The Tombs at six o'clock.

Chapter Sixteen

PROMPTLY at six, Salome descended the steps to the subterranean tavern. The Tombs had undergone expansion and gentrification since the mid-1960s when Gabe and Jude had been students at Georgetown, and since Salome had been included after Gabe's tour in Vietnam. Though cleaner and more polished now, the tavern still had plenty of charm and would always be imprinted with their youthful exuberance and idealism.

Jude was not alone. In a booth compartmented by lovely etched glass, he and Gabriel Hoya huddled over mugs of beer like a pair of conspirators.

Gabe stood and they embraced.

"Hello, Mei," he said.

"Gabe. Good to see you."

"You mean that?"

"Of course!" Salome slid into the booth.

"What'll you have?" Gabe asked.

"Whatever you're having."

Gabe grabbed their server's attention and ordered a beer for Salome.

"Tell Mei about your latest adventures," Jude said.

"If you're talking about finding a body, I saw you on the news last night. Might be a good idea to archive those pants."

Gabe cringed, then actually blushed, for a moment quite boyishly appealing.

"How did Elle react?"

"Badly, no doubt. Thing is, you see—"

"That's only part of it," Jude interrupted.

Gabe proudly regaled her with details of destroying his desk, leaving Elle, and moving into the Georgetown Inn to write.

"But then, I did quit smoking last week."

"That mule carries a lot of loads," Salome said wryly.

"Having never been a smoker, you wouldn't know the havoc associated with quitting."

The waiter appeared with Salome's libation. When he left, Gabe went on, "As I recall, you pooh-poohed the desk when you saw it."

"Doesn't mean tossing it into the swimming pool was such a brilliant idea."

"Call it Men's Feng Shui."

Jude lifted his glass, "Big honkin' TVs!"

Instantly connecting with his friend, Gabe clicked Jude's glass with his own. "Underwear by the bed!"

"Muscle cars!"

"Kegs of beer!"

"Woofers!"

"To Men's Feng Shui!" the two men declared, boyishly delighted with themselves as they raised their glasses.

Salome found herself laughing.

"No offense, Mei," Jude said.

"No, no. I suppose plenty of people regard crystals, wind chimes, and such as wimpy." She sipped her beer and addressed Gabe. "Jude told you about the fire?"

Gabe's happy expression fluttered away. "We should have nailed that bastard, Mah, last year."

"We?"

Gabe and Jude regarded each other with a you-want-to-tell-her-or-should-I? expression. Finally, Gabe said, "J. Freeman Investigations is now J. Freeman and Associates. If you recall, we talked about this last year. In your basement."

"Of course, I remember. But you seemed to treat it as a lark, a

resurrection of 'The Mod Squad,'" she said and made a face. The
television show of the same name had been quite popular in the
1960s, the trio of detectives comprised of one black, one white,
and a blonde woman.

"Timing wasn't right then. Now it is. I just bought into the
business. Gave Jude a check for ten thousand dollars. So. I've
stopped yammering and done something about it. You've been
helping Jude from the get-go, when things were really tough."

"Yes, but regarding Mah, my efforts have been perfunctory at
best. To be honest, I hoped he would just go away."

"And now a real death has landed in my lap."

"I hope you're not confusing actual investigative work with a
desire for new material," Salome remarked.

"My two cents?" Jude interjected. "We all help each other. Of
course, I'm the only one with a license but just like you, Salome,
Gabe can research and talk to people. Doesn't matter to me, our
cases turn into fiction. Just so long as certain details—like real
names and such—are left out."

Salome started to speak. Gabe hushed her with a raised hand.
"Just hear me out. I'm not exploiting Honey Lee, not totally. I just
don't believe she killed herself."

"What do you know about her?"

"Elle heard about her from friends—women who work hard
trying to outdo each other. She—Honey Lee—was Chinese; I'd
say about twenty-five, spoke English well, attractive, and had
some wealthy, high-powered clients, which made her hot, cer-
tainly to the more modestly wealthy like Elle. Apparently Lee
started her organizing business a year and a half, two years ago.
Still, I ask you, how could she afford a house in McLean? Even to
rent. We paid her fifteen an hour. She may have charged on a
sliding scale, the super-rich paying more. Tomorrow I'll check
county property records to see who owns the house."

"Perhaps she's married. Or had a roommate."

"I don't think so."

"Will you be contacting Dick Sullins?"

Gabe suddenly beamed and leaned over to hug her. "God, I've missed you! Dick Sullins."

Back when Salome and Gabe were married and worked together on his books, Sullins had been a valuable contact. A homicide detective with the Fairfax County Police Department, he had always been willing to share information with Gabe. The couple relied on Judah for procedural details, but Jude drew the line at disclosing details of open cases. A hard drinker, Sullins liked to bar-hop with Gabe and at times took him to crime scenes once they had been released. It was Sullins whom Gabe had thought of calling after seeing Honey's body, the detective's name he had been unable to recall.

"Bet he'll get me the coroner's report. As a rule, homicide detectives don't break a sweat trying to prove a suicide is a homicide unless there are some pretty obvious clues around."

Jude said, "That's because they usually are what they appear to be." For a moment he appeared doubtful of agreeing to the partnership. But then he had actually been a cop.

"But not always."

"Look, Gabe, I know you're sick of writing this romance but don't try and turn a suicide into a homicide just because you're starving for a good mystery," Jude said. "Looking into her death is fine but draw the line at creative speculation."

"It's just something Elle said recently. And here I go with memory troubles. Well, not totally. She's been a pain in the ass and I've tried to ignore her as much as possible. Thing is, she now fancies herself as a fashion designer. She said Honey knew where she could get seamstresses cheap. The 'cheap' part imprinted itself since I've been hemorrhaging money getting her business off the ground. I swear, if I don't divorce her soon, I'll be bankrupt."

"You might be bankrupt if you do divorce her."

"Speaking of divorce, how's yours?"

Jude glanced at Salome, then looked at Gabe.

Salome said, "You can talk in front of me, Jude. I'm not going to carry tales between you and Cookie."

Oddly, Jude began to laugh. His laughter was so deep and booming, the hilarity spread instantly, though Salome had no idea what she was laughing at.

When he quieted, Jude shook his head. "I was just thinking about Men's Feng Shui and the stuff Cookie and I are dividing up. Every ugly piece of furniture we've got—we had—Cookie says is mine. Lord Almighty, big and ugly must be how she thinks of me." He slapped his hand on the table. "But the good news is, Chimene's right on track to get back into Georgetown. Maintaining a four-point at George Mason."

At the mention of Jude's daughter, Salome tensed and returned to the topic they'd been discussing.

"What were you saying about seamstresses?" Salome prompted Gabe.

"Right, right. Well, I got to thinking, seamstress plus cheap labor, well, doesn't that often lead to illegal immigrants? What if Honey came to the States illegally? What if Honey knew Duncan Mah? I mean, the Asian community here is very insular and I'm betting that a lot of people at least know of Duncan Mah."

Salome smiled and told them about calling Howard Chen, publisher of the *All Asian-American Gazette.* "This being Sunday, he wasn't in but I left a message asking for an appointment."

A few moments later, after they finished their drinks, Gabe suggested they find a place to eat.

Leaving The Tombs, they headed down Prospect, taking the "Exorcist" stairs, made famous by their inclusion in a scene of the movie of the same name, down to M Street.

"So how is Chimene?" Gabe asked.

"Can you believe it, she got herself a part in a movie!" Jude touched Salome's arm. "She told me about Friday night, how she wasn't able to give you a ride home."

Salome smiled in relief, glad she no longer had to keep that secret.

"What's the part?" Gabe asked.

"A successful career woman."

They walked east on M Street, the air positively crackling with energy from the young crowds, chatty and seemingly without a care, filling the sidewalks and spilling out of restaurants, waiting for seating.

"Should have stayed at The Tombs," Jude lamented.

"Oh, I don't know, it's fun being out," Salome said.

"Listen, I'm too hungry for this. Why don't you two go on."

Both Gabe and Salome were taken aback by the suggestion. Salome couldn't remember the last time they'd been alone. She suspected Jude's motives but before either of them could protest, Jude flashed a bright smile and headed back to his car.

"Let's talk tomorrow!" he called out, then disappeared into the crowd.

"What do you feel like?" Gabe asked, looking remarkably shy.

"Gosh, I don't know."

"Want to take a cab someplace, maybe downtown?"

"Let's just walk."

"Sounds good to me. We'll play it by ear."

For over an hour they walked, now more intent on each other than the activity around them. Gabe regaled her with amusing stories of the romance he'd been writing. Finally they ended up practically back where they started and decided to eat at Clyde's.

The pleasure she'd once enjoyed in Gabe's company returned full force.

"Whenever I start to sink into depression—not to be confused with general frustration—all I have to do is conjure up our first night in the town house. Romping around like five-year-olds. Remember jumping up and down on the bed?"

Eyes twinkling, Salome reminded, "And breaking it."

"What marvelous fun."

"I still have that story you wrote about that night. The passage describing the frost on the window the next morning is perfect

summer reading—good as air-conditioning—that is, until it gets to the sexy bits. Then, well, the rest is best read on a cold winter night."

Finishing the meal, they headed toward Georgetown University, both unwilling to go their separate ways just yet.

Finally, Gabe said, "Heard you went to Jamaica with your old high school flame."

"Michael O'Kelly."

"Have a good time?"

"You're thinking romance, right?"

"Well, yes."

"So was I." She paused and took a breath of the flower-scented night air. Somewhere nearby must have been night-blooming jasmine.

"Turns out," she continued, "he asked me there to consider an old plantation house for sale. He was thinking of turning it into a B and B and thought I'd loan him the money."

Gabe grunted. "Did you sleep with him?"

"No, thank God. But I probably would have, had he not made the proposal as soon as we arrived. Silly me, I thought he had a different kind of proposal in mind."

"Guess it put you off old loves."

"That one, anyway."

Gabe smiled, then glanced down at her and tentatively took her hand as they continued to walk. She firmly held on to his, and a few moments later they were standing at the top of Malabar Close.

For a long moment they stared at the house. Then he turned and pulled her toward him. Just then, a security guard stepped out of a sedan parked in front of her house.

"Can I help you folks?"

Blushing slightly, Salome introduced herself. "Indirectly, I'm the reason you're here," she said and fished out her driver's license.

They chatted briefly—he said that so far, it had been quiet. He

returned to his car and Salome and Gabe moved down the street, out of the guard's line of vision. They kissed, as if for the first time, shyly, then, something awakened in both of them spontaneously and the kiss moved into a deep embrace.

"What are you thinking?" he asked when Salome pulled away.

"The phoenix rising from the ashes. And you?"

"Just how much I've missed you."

Salome looked away, somewhat stunned by this unexpected development.

"Look, would you help me out with this Honey Lee thing? I mean, that's not the only reason I'd like the pleasure of your company. We always worked well together. The rest, well, we can take it slow."

"That's good. Because I don't date married men."

"Care to make an exception of the married man with whom you were married, and soon to be unmarried?"

Salome laughed, reminding herself of life's extraordinary twists. As the ch'i moves, so we'd best follow.

Chapter Seventeen

RAIN WAS falling Monday at noon when Salome opened her umbrella and stepped out of the Austin-Healey 3000, which she had collected earlier from Foreign Service on Chain Bridge Road in McLean. Again missing Dario Burgos, she asked about him, only to learn he was visiting his mother, a professional tangoist, in Buenos Aires, and would not be returning until the end of the month. Yet even when contemplating the handsome mechanic, she found that Gabe was not far from her mind. At the moment, she didn't fully trust him—or rather, his emotional state. She would just have to wait and see what happened. Still, she looked forward to their dinner date tonight at the Georgetown Inn.

She hurried across the packed parking lot, and closing her umbrella, entered Eden Center. The office of the *All Asian-American Gazette* was located inside an arcade of Asian shops, the *Gazette* flanked by a hairdressing salon and a curio shop featuring large and small pots of lucky bamboo on shelves in the window.

A bell jingled as Salome entered. A petite Vietnamese woman, casually dressed in black slacks and a pink cotton blouse, lowered a steaming bowl of noodles, placed her chopsticks across the bowl, and blushed. Salome gave her name and the woman went to a nearby door and knocked, then stuck her head inside. Salome heard a steady *snick, snick, snick* of someone typing on a keyboard.

A moment later, the receptionist smiled politely and motioned for Salome to enter. The man at the single desk raised a hand, then went back to typing, his focus on the computer monitor

intense. Salome took the opportunity to examine the newspaper publisher's sanctum, quickly determining that he needed a cleaning service and Feng Shui consultation—in that order.

Plaques, framed citations, and photographs of Chen smiling and shaking hands with various politicians and Asian dignitaries were arrayed on the wall behind him with no sense of order or design. All needed straightening, and the glass given a good swipe with a dust rag. In the wealth gua, on top of a short refrigerator, sat Lord Buddha, an offering of oranges on the plate before him.

The room smelled sharply of tobacco and incense, with a hint of disinfectant: it seemed to permeate the yellowing walls and furniture. Two straight-back chairs at a long table with papers and newspapers swirled on the surface held the overflow. A plant in a blue-and-white ceramic pot wilted in the relationships gua.

The door to a small bath stood open with a view of the toilet, a tin teapot on the commode; the bathroom, she reasoned, was the source of the scent of disinfectant.

Salome continued standing until Chen dramatically tapped one key, then spun around and extended his hand across the desk.

"Ms. Waterhouse. I'm Howard Chen. Please, clear off a chair and sit down. Would you care for tea?"

"No thank you," she said, put off by the sight of the teapot on the commode.

"I need something." He went over to the refrigerator and retrieved a can of orange soda, gave Lord Buddha's smooth head an affectionate pat, then sat down, taking a long pull of his beverage until his cheeks expanded. He swallowed loudly, and his cheeks shrunk back to normal.

"Bad news, Duncan Mah. James Wong, whatever. Bad news. Now good news, that's our staple. When the Asian community wants bad news they read the *Post*. Our subscribers like to read about friends and relatives succeeding in business, winning beauty contests and sports awards; who's visiting China, Vietnam, et cetera. Our advertisers reflect content: beauty shops, travel agencies, and so on. Everybody's happy!"

"But you said on the phone when I made the appointment—"

He held up a hand. "I know. I know. Me, I'm a journalist at heart. Bad news is my rice. So, I write articles, investigative pieces, editorials, under a pseudonym, of course. Still none of the big dailies send me anything but rejection slips."

He made a slight face, then abruptly rose.

Salome feared another dead end; her disappointment must have been obvious.

He grabbed his coat from the back of his chair and swung it over his right shoulder. "You hungry?"

Salome brightened. "Starved."

After a brief word with his receptionist, they set off, just a few doors down to a noodle shop. Over large steaming bowls of flavorful broth and noodles, Chen began.

"I'm the son of Fuzhounese immigrants and grew up on Manhattan's Lower East Side. Most other Chinese considered us pariahs, *gan-she-qui*, or 'fearless ghosts.' That's because we would operate businesses where nobody else would, in the worst parts of the city. Everybody hustled. I started working at five years old in a filthy nonunionized garment factory with my mother.

"Our family saved money—no time to spend it! When I was ten my father opened a business, *fuwu gongsi*, a service company that purchased U.S. documents for people: driver's licenses, Social Security cards, work permits. Finally had money to leave—my mother was so happy. From our tiny one-room apartment we could see the Manhattan Bridge above us, which my mother thought was an evil dragon.

"ABC girls—American-Born Chinese—are popular with single Chinese men. They get up to three thousand dollars to agree to bogus marriages so an illegal suddenly has legal status. I had a cousin who married five times." He suddenly laughed. "She's Catholic, too. Doesn't believe in divorce."

He paused to eat some more noodles, then continued. "Illegal immigrants have to do illegal things to stay here. And as you

can imagine, they're terrified of the INS and the police. Won't talk to anyone outside their community, won't go to the doctor when they are sick. Remember, Snakeheads charge thirty thousand dollars and up for passage on a stinking tub from China. When they get here they have to pay off the debt. Someone like Duncan Mah, he'll broker grunt-work jobs mainly with service industries—hotels, dry cleaners, restaurants, industrial laundries—businesses glad to pay low wages to what are euphemistically called undocumented immigrants. Hell, slaves, that's more to the point. They work themselves to death to pay off their debt."

"How does it work? Someone I know wants to hire seamstresses for a clothing business."

"You talk to a Chinese subcontractor—a guy like Duncan Mah or someone who works for him—about your job order. He hires the workers, the same people working off their debt to him. Sometimes the subcontractor provides housing and transportation to and from the job site, which means he has total control of their lives."

"Did you know the Chinese woman who allegedly committed suicide? Honey Lee?"

"I didn't, not personally, but rumors are flying. Being a hairdresser, my wife hears all the gossip. Apparently, Ms. Lee was ambitious and had a very high opinion of herself. She did not fraternize with other Chinese, or any Asians for that matter. Can't trust the gossip, of course, since no one really knew her. When something like that happens, a suicide or a murder, though, everybody's interested. The Asian communities are very clannish. Some groups don't even speak to each other—like I said before about the Fuzhounese. Here in the D.C. area, we're not like the big Chinatowns in New York City and on the west coast. If we want to be a force, protect our rights and have equal opportunity under the law, we have to come together. That's why I call my paper *All* Asian. Also, I set an example by marrying a Vietnamese

woman. She owns the hairdressing shop next door to my office. So many immigrants bring their provincial boundaries and prejudices with them to America. This is wrong and further isolates people. Duncan Mah—James Wong—he likes that. Better for him to have people dependent on him."

"What does he do with the people when they arrive?"

"Gotta keep them somewhere, right? Some place nobody cares about or pays attention to."

"Would he own property?"

Chen frowned and shook his head. "His business is illegal. Unless he marries, he has to stay in the shadows and move around."

"Doesn't seem like a pleasant way to live."

"Hey." Chen shrugged. "Snakeheads, all they care about is the money. Greed consumes them. How they get money doesn't matter. They have no connections to people or places, not like most of us. Still, he will not live in squalor like the people he exploits."

After lunch, Salome thanked Howard for his time. He extracted a promise for her to share any new information she might uncover. "You find Duncan Mah, and survive, let me know first! I want to break the news."

The "survive" part was a bit frightening, but she agreed, and added, "It might be advantageous to meet your wife. Does she speak English?"

"And French," he said proudly. "Whenever you want your hair done, call me. I'll set up an appointment." Being a newspaperman, he probably discounted the gossip readily available at a place like a beauty salon. Even so, tidbits of actual fact could be plucked from the general chatter such establishments were famous for.

Delighted to have her car again, Salome spent the afternoon shopping. Among her purchases were some personal items, burners and matching trays for the stove at the Women's Place, and five pounds of smoked salmon, which she personally delivered to the Georgetown fire station. Nathan Barnes was not there so she

left him a note thanking him for the suitcase of clothing he'd so thoughtfully provided for her.

By the time she returned to AAWA, it was time to dress for dinner with Gabe.

Wearing silky ink-black trousers and a brilliant white Mandarin-style jacket, frogs and trim in black, she was led to a table in the dining room of the Georgetown Inn. Hair shining like black satin and pulled back in a thick bun, large pearl earrings complementing the luster of her skin, Salome received any number of admiring glances as she walked to the table, from all but Gabe himself. His attention was focused on a martini, her arrival startling him.

He jumped out of his seat and pulled out a chair for her. Placing her new black-and-white beaded clutch bag on the table, she regarded him with concern, beginning to think this dinner date had been a bad idea. Both his blue shirt and khaki trousers were wrinkled, and she wondered if he'd simply plucked clothes from a pile of laundry. But his face had been freshly shaved, his hair washed, and she could smell soap. She noticed the gold band on the ring finger of his left hand. When they had been married, neither of them wore wedding rings.

"You okay?" she asked.

He shook off his funk and stared at her for a moment. "My God, you look stunning."

Salome beamed.

"Let me get you a drink. And don't say 'water.' Please."

"All right. I'll have a dirty martini."

He summoned the waiter and placed the order.

"Where'd you learn about dirty martinis?"

"We've been divorced over six years and I have actually had a life since. Apparently, you need a drinking companion tonight," Salome remarked. "So what's happened?"

"Elle's shoe boxes. Big boxes. What's more telling? What you see or what you don't see?"

Before she could answer, the waiter brought her drink. She

took a sip, enjoying the flavor of the olive juice, which gave the gin martini its name.

The waiter asked if they'd like menus. Gabe declined, saying they would wait.

When he left Salome picked up where they had left off. "What you want to see rather than what you do see."

Gabe leaned back in his chair. "Not the answer I was looking for but…you're exactly right."

"So what are we talking about?"

"Epiphany. Elle stores her things in the basement, contents and dates neatly written on the boxes in Magic Marker. It's like a storage unit for the fashion section of the Smithsonian."

Gabe drank his martini and then continued. "Last night I woke up about three A.M. and realized not one box had 'Tyler' written on it. Not one. I don't much like the kid, but having come to the realization that his mother is so totally selfish, self-absorbed, I feel sorry for him. Poor kid, stashed away in some military school.

"Anyway, around six, I drove back to the house. She had just gotten up, was in the kitchen making coffee, getting ready for another day of screwing me. I told her I'm divorcing her, and left. First hurdle crossed."

He finished his drink. "Who thinks of doing background checks on people they fall in love with?"

"Good grief, Gabe, it's a good idea, especially if one party has healthy finances and the other party does not. Not to mention the pre-nup, which has been around for a long time."

"Yeah, but hardly romantic."

"And look where that romance got you."

Over an excellent dinner of crab cakes, Gabe brought up his investigation into Honey Lee's death. "I've got a breakfast meeting with Dick Sullins."

"Good going, Gabe."

"And not only did I find out who owns the house, I set up a meet. So, if you will, this is what I'd like you to do.…"

After he outlined his plan, Salome reached across the table and squeezed his hand.

"Care to see the etchings in my room?" he asked.

Salome gave his hand a swat, then retracted her own. "Stick people do not impress me."

"That's the trouble with courting an ex-wife. She knows you, too well."

Chapter Eighteen

AT AROUND ten the following morning, Salome parked on the street in front of Honey Lee's house. Stepping out of the car into a warm mist, she crossed the street for a better vantage point from which to examine the property and neighboring homes. In a direct line with the front door stood an old maple tree. Some Feng Shui practitioners consider this configuration the worst, as any blockage to the entrance to a dwelling prevents the ch'i from entering. Of course, there are solutions but for decades, this house had suffered the equivalent of the blockage of a major artery.

She looked around at the nearby homes, looking for sharp edges, intrusive utility lines, or anything that might shoot poison arrows at Lee's residence. While examining the house directly across the street from Lee's, she noticed a curtain move at the front window. A lawn sculpture/wind chime that had the unfinished look of a homemade structure featured what looked like a ceiling fan, a bell attached to each prong. The prongs were of thin, sharp-edged metal. In the misty air it remained motionless.

A woman stepped out on the porch, arms folded at her chest, a pose both defensive and challenging. Salome smiled and strode purposefully up to the woman and introduced herself.

"Hello, I'm Salome Waterhouse. A friend and I are looking into the death of your neighbor."

Relaxing her pose, the woman moved down the two steps to Salome. "Shelley Hicks."

"Did you know Honey?"

"Well, she did my ironing. When she first moved in, I guess it was about a year ago, she went around the neighborhood offering her services—housecleaning, laundry, ironing. At first I just wanted to help her out a little. But damn, she did such a marvelous job I gave her whatever didn't need to be dry-cleaned. Probably sounds excessive, but she even did my sheets and pillowcases. I've never slept better. I'm spoiled now."

"Had she been depressed lately?"

"Ha! Depression's a luxury hard-working people can't afford. I can't remember exactly when, maybe a year ago, she asked if I wanted her to organize my household. She gave me a business card saying she was a professional Organizer. I declined. Ironing was enough and I like my messes just as they are. She got a little huffy and said my house probably wasn't big enough anyway." She checked her watch. "Speaking of organizing, I need to get back to work."

"What do you do?"

"I'm a painter. And I teach art history."

"Just one more question, if you don't mind. What about visitors or a boyfriend?"

Shelley remained silent for a long moment as if balancing information on a scale with discretion. "Lately, no love interests that I ever saw. Mind you, when she was home she just seemed to work all the time. Lights were on in the basement late every night. But when she first moved in, there was a man who used to come by a couple times a week. But not on weekends. I thought he might be married. That petered out. Now that I think about it, his visits became less frequent after she started her 'organizing' business. Could be, she was just too busy to see him."

"Can you describe him?"

She sighed. "Caucasian. Had a military bearing, non-color buzz cut. Older guy. A lot of men around here fit the description: government, military types. Now, I really do need to get going. But I will say one thing—Honey was always thinking ahead, one of those people who live in the future as much, if not more, than

the present. That young woman had plans and I seriously doubt if hanging herself was one of them."

"Thanks for your help," Salome said.

"If you find out anything new let me know," Shelley said, and with a wave of her hand, entered her house.

Salome started down the slightly sloped lawn.

Gabe sped up the street and parked in front of Salome's Healey. A moment later a new Lincoln pulled into Lee's driveway. A man of about sixty exited the car and approached Salome and Gabe. Just a short time ago, Shelley Hicks had described just such a man. Now she understood the 'non-color' reference to his hair.

"Colonel Horn, my ex-wife, Salome Waterhouse. Salome, this is Colonel Paul Horn."

"Retired army," Horn added.

"Since you're looking for a place to rent, Colonel Horn kindly agreed to show the house." Gabriel gave her a big, toothy grin and earnest look.

"A pleasure, Ms. Waterhouse. Gabe told me about your unusual profession."

"Nice to meet you. You were a friend of Honey Lee?"

"Let's go inside, shall we. And please, call me Paul."

Entering an unadorned, narrow, recessed entryway, Salome and Gabe stood behind Paul as he pulled out a ring of keys and unlocked the front door. Salome pulled out a notebook, quickly jotting down a description of the entrance, noting the dark, stagnant atmosphere, familiar to her in houses she'd visited in which murder had been committed.

Paul pushed the door open and switched on a light in the tiny foyer. "Bedrooms to the right, living and dining rooms to the left. Kitchen is in the back. Frankly, I feel a little strange showing it so soon after Honey's death. But, hey, who could pass up the chance of having a character named after them in Gabe's next book."

"Indeed," Salome said and looked at Gabe. Then addressing Horn she said, "Would you mind leading the way?"

"Oh. Well, certainly."

"I'd appreciate a little history, too. That's a major consideration in Feng Shui. Who the previous tenants were, what they did: that sort of thing influences the overall energy."

The first room he led them into was a bedroom furnished with an early-American–style bureau and a queen-size futon bed with a cherry frame.

"Will Ms. Lee's relatives be picking up the furniture or does the house come furnished?"

"Actually, the furniture's mine. I have numerous properties, condos and houses, some furnished, some not. I do charge a little extra for a furnished place. Mostly I rent to military families in the area. Sometimes they need furniture. Especially if they've just arrived in town from an overseas posting they need a few things before their household goods arrive."

Colonel Horn showed them another small, sparsely furnished bedroom and a bathroom.

They entered the kitchen. All-new appliances sparkled. "She must have worked very hard to afford a nice house like this." Salome opened the cupboards; one beside the stove revealed bear-shaped plastic containers filled with HEAVENLY HONEY. Not a national brand; on the white label below the name was HEAVENLY FARMS, ALEXANDRIA, VA.

"Well, to be honest, I gave her a break."

"Really?" Gabe said. "How about that, Mei."

Salome turned from the cupboard.

"A softhearted landlord. How'd you meet her? She answer an ad in the newspaper?"

"Actually, she used to baby-sit for us. My wife and I both work full-time taking care of our properties. We kept the grandkids while my daughter and son-in-law were in Saudi Arabia. He works for an oil company and they wanted the kids to stay in school here. That was what—two, three years ago? Hard to believe how time passes."

Salome finished her inspection of the cabinets, and peeked un-

der the sink. From what she'd seen so far, Honey Lee made her look slovenly.

"What was she like—other than obviously neat and tidy?"

"Smart girl. Very bright. Hardworking. And an excellent tenant. Wish they were all like her."

A moment later, they descended the basement stairs. At the doorway, Paul hesitated, reluctant to go further. "Why don't you two have a look around? I've got a couple calls to make. Don't know if my cell will work down here. I'll just use the kitchen phone."

"We shouldn't be long," Gabe said.

They watched as he hurried back up the carpeted stairs and returned to the kitchen.

Salome and Gabe didn't speak until they reached the middle of the full basement.

"What did you tell him?" she asked.

"That Honey worked for me and you were looking for a place."

"He must think we're both ghouls. Jumping on the place so soon after her death."

"His wife insisted he show the house. He wasn't keen at all. She didn't seem the least bit concerned. As far as their home business goes, she seems to be the one who runs the show. Not someone I'd want to live with. But," he added with a smile, "she's a fan, knew my name right off. I signed a couple copies for her."

Salome examined the room with interest. A magnetized plastic container for holding loose change and whatever might be left in pockets was affixed to the front of the top-loading washing machine. A white cabinet next to the washer contained laundry supplies.

Shelving, an ironing board, a counter for folding, a small television set, and a rolling trolley were located on the other side of the basement along with another rod and more hangers, these heavy white plastic.

Like the rest of the house, the basement reflected the single

resident's natural inclination toward—or obsession with—cleanliness, neatness, and organization. Anyone not giving her death much thought would consider it a fitting place for such a person to end her life. Or to have her life end.

Salome looked at the inflatable hangers on a rod in front of the dryer. Using a tissue to prevent leaving prints, she opened the door to the dryer. The interior light revealed about a half dozen knit polo shirts inside. Reaching inside, and without a tissue, she felt the shirts. They were dry. She held one up. It looked like the one Paul Horn wore, with its own golfing emblem. Not uncommon but still...

She called Gabe over. "Look at this."

"A polo shirt. So?"

"Given the woman's character, it's unlikely she'd have left these shirts in the dryer. Over in the cupboard are deflated hangers and a little pump. She must have inflated these hangers," she indicated the six on the rod, "in preparation for hanging up these shirts. You hang a knit shirt on a regular hanger and you'll get these little pokey bits on the shoulders. Inflatable hangers prevent that.

"If a woman like Honey Lee was going to kill herself, she wouldn't do it before taking the shirts out of the dryer."

"Seems irrelevant."

"No it's not. You don't take care of your own clothes. You don't clean. I know how people who perform domestic chores think. Here's a clue to tell you she did not kill herself," Salome said with complete conviction. "And her landlord knows a lot more than he's saying."

"You don't think he killed her, do you?"

Leaving the question unanswered and having seen enough, Salome led the way back upstairs.

Paul Horn stood at a window looking out at the back garden. He started as they entered.

"Well? What do you think so far?"

Salome didn't speak, just stared at Horn. Under the intensity of her gaze, his demeanor changed as his composure fell away.

"Honey Lee was in the country illegally, wasn't she?" Salome said, abandoning the pretext of renting.

"Oh Christ! You're from INS, aren't you?" His eyes shifted to Gabe and shot daggers. "She's dead, goddammit."

"Why don't you sit down, Paul," Salome said, her tone calming. She went into the kitchen and filled a glass with water from the dispenser on the door of the refrigerator/freezer.

"What? The state won't bury her? I couldn't claim her body. If my wife found out, well, believe me, there'd be hell to pay."

"She was your mistress?"

He took a sip, then set the glass down so hard water sloshed over the side.

"Honey really didn't seem to care. She was totally immersed in her work. At first, you see, she wanted me to leave Marjorie and marry her. She had some forged documents, a Canadian birth certificate, driver's license, all that. Still, she was afraid of her sponsor, apparently a relative who'd brought her over illegally. From what she told me, he's a pretty scary guy. I gave her some money to pay him off. He always seemed to want more. Finally I just said, no more."

"Aside from what she told you, what did you actually know about her?"

Looking grim, he sat back in the chair. "For one thing, she didn't live where she told me she lived when she first started working for us. She'd usually take a bus home. One night she accepted a ride. I drove her to a run-down apartment complex in Alexandria. Then one time, I parked and watched her. Instead of going into the building, she waited out front. After about twenty minutes, a van picked her up. Had the name of some church on the side. I was curious so I followed the van out a ways. Just outside Alexandria, it turned off Route One and headed east. There was an old church and some outbuildings. Couldn't see all that much as it was getting dark. Turned around when I reached a jetty.

"Next time I gave her a ride I questioned her about where she

lived and I told her I'd followed her. She said the church housed people temporarily but if I could help her find a new place to live she'd be really grateful.

"I took her to dinner, and well, that was the beginning of the affair. I offered the house, this house, to her at a very reduced rate. She said she had some things to settle and then she'd move in.

"Anyway, when I asked more about the church complex she said it was run by a Chinese-American Christian organization. Without telling her, I checked out the property. This Christian group leases the buildings from a corporation in Alexandria. All quite legitimate."

"Did she tell you the name of her sponsor?" Salome asked.

"No." He finished his glass of water.

"What did you think when you heard about her death?"

"I was stunned."

"Yes, but did foul play ever enter your mind?"

"No. I thought it was my fault. That she killed herself because of our break-up. In fact, that's what I wanted to believe, no matter how insensitive that sounds. Because the last time I saw her, the night we broke up, she was happy. *Radiant.* I think that upset me as much as the break-up. You see, to be honest, she broke up with me," he confessed, his ego taking a beating—one long-overdue beating, Salome thought.

"Was there someone else?"

He snorted. "I asked her the same question. She laughed and said, no way."

"During your time together did you ever meet her friends or did she talk about friends or family?"

"As far as I know, Honey was completely on her own. She never mentioned anyone—aside from her sponsor."

"Not even anyone from the church?"

He shook his head. He seemed to have aged considerably in the hour they'd been in the house.

"Let me give you a card," Salome said, reaching into her shoulder bag. "If you think of anything else, call this number."

He read the card. "J. Freeman Investigations? Will my wife have to be questioned?"

"At this point I can't say."

"So where's the church?" Gabe asked.

"I really can't tell you exactly. I was just, well, following without really noting landmarks. Didn't seem like a big deal at the time. A mile or two east of the turn-off."

They walked through the living room and out to the entryway. As Paul locked the front door, he said, "Well, if you do talk to my wife, I'd appreciate it if you'd avoid mention of my personal relationship with Honey. It's just not relevant."

"But Colonel Horn, you said your first thought was that she'd killed herself because of you. That sounds relevant, to me."

Salome turned and strode to her car. Gabe came to the driver's side and motioned for her to roll down the window.

"Know what he asked me?" Gabe said. "Asked if I was still going to name a character after him."

"If you do, make sure it's a snake."

Gabe waved to Paul Horn as he backed out of the drive and sped down the street.

"Where you off to?"

"Back to the District. You?"

"Lunch date with Dick Sullins."

"Don't drink too much, Gabe."

He seemed to remember something. "Bought myself a new cell phone. Here, let me give you the number."

While she jotted the number in her notebook, Gabe said, "Meet for dinner?"

"Sure."

"I'll pick you up at six."

"Fine."

Chapter Nineteen

MAY McGANN lived in a gray Georgian Revival mansion, circa 1910, a couple of blocks north of AAWA.

Salome followed the circular driveway to the front door, passing various mid-size cars either in need of a wash or body work. Between the drive and the street was a half moon of new grass bordered by perky yellow daffodils.

A rotund young woman wearing tattered jeans, T-shirt, and a bright red bandanna opened the front door. Lavender-tinted glasses were perched on her small nose.

"Gran's in the kitchen at the end of the hall," she said, and Salome entered. Classical music and rock 'n roll drifted down a set of wide stairs to the right, intermittent hammering adding to the mix. To the left, Salome saw two young men removing wall-to-wall carpeting.

"Renovating?" Salome asked.

The girl beamed. "Gran's letting me redo the whole house for an interior design project."

As they walked down the passage, creaking floorboards added their own noise. A miniature poodle leaped off a chair and yapped at Salome's feet as she crossed into the bright, sunny kitchen. The scent of baking bread filled the warm room.

May McGann moved from behind a six-foot-long butcher-block table to the left. Her cheeks were bright red spots of color in her round face. Wiping her hands on a chef's bibbed apron, she extended a hand.

"May McGann. Though we weren't introduced, I remember you from April's birthday party last year."

"A memorable evening all around," Salome said, feeling an instant rapport with this woman so very different from her two sisters.

"Well, I'm delighted to meet you, Salome. Today is baking day so I hope you don't mind if I continue while we talk."

"Not at all. Thank you for agreeing to see me."

"Don't really know what I can do to help." May began putting force into kneading dough.

"You cook with honey?" Salome said, and tilted a two-pound can to read the label: HEAVENLY HONEY, HEAVENLY FARMS, ALEXANDRIA, VA.

"A habit begun when I lived in a commune. As I used to say, 'back in the olden days'."

"Heavenly Farms," Salome said. "I just came from a house where the same brand was in the cupboard, the honey in a bear-shaped container."

"I buy it at a health food store. Heavenly Farms—that's where the commune was. We were very self-sufficient, grew all our own vegetables and kept bees. I've never been healthier. Or happier."

"What changed?"

Finished with kneading, she patted the dough into a round, then set it in a large ceramic bowl, which she covered with a damp tea towel.

"Coffee? Tea? I've got both. My granddaughter's into herbal teas, the boys like their caffeine."

"Tea would be fine. Whatever you have made."

May poured two cups of tea from a sturdy white pot, and carried them to the oval oak kitchen table where a pile of cookies was cooling on a Mexican platter. A lazy Susan in the center of the table contained a creamer, natural brown sugar, and a honey pot.

Salome sipped the flavorful tea and waited. May added a large dollop of honey to her steaming mug. The poodle jumped up on her lap.

"What changed?" May repeated, and absently stroked the fluffy dog. "Well, just about everything. I got pregnant, got busted, and got disinherited all at about the same time."

"One of those vegetables…?"

May laughed, a wispy cloud of flour rising from her hefty bosom. "Dad kept me out of jail but he and Mother both wrote me out of their wills. It's only been in the last couple years that I've been on speaking terms with my sisters. On the phone you mentioned wanting to discuss Duncan Mah. Yes, I met him. Seemed pretty obvious to me he was after April's money. Though I hate to say it, sometimes I wish she had married him and he took her for everything. You see, there's something of a nasty history between me and my sisters."

She bent down and kissed the head of the dog.

"I've never really gotten over the betrayal, probably never will. I used to work hard at forgiveness. We were all good Christian kids at the commune. With money from a trust my grandfather set up for me, I bought the place in part because of the old church. We fixed it up really nice. Some of the folks who lived nearby used to join us for Sunday services." She looked away for a moment before continuing.

"And then, I made the mistake of inviting April and June to spend a weekend. June came up from Randolph-Macon; April came down from New York City where she worked as a fashion model. What a mistake. I've never been so embarrassed in my life. Neither of them had the courtesy to even try to show interest in my friends. June regarded them as intellectual inferiors; April snubbed them for being middle-class. Instead of staying two nights, they both left after dinner. Around midnight the cops arrived. My boyfriend at the time, a really sweet guy from Berkeley, was shot in the head by a cop who said he'd seen Joey reach for a weapon. It didn't help that Joey was black. He died two days later.

"I don't know if they both called the cops or just one of them did. Maybe they called my parents and told them about the pot, and Dad or Mom sent the authorities. No one has talked of it

since. But what am I to think? Everything had been fine until the night they came to dinner."

"What happened to the farm?"

"I sold it to help with everyone's legal fees."

"Do you know who bought it?"

"My mother. She put up some low-income housing. The church was leased to some Baptist organization.

"With the money left in my trust fund I split. Bummed around Europe, spent about a year in India and Tibet, then settled in a little town outside Liverpool, married a local, and opened up a bakery. We divorced after ten years. I brought my kids to D.C. mainly to give them the opportunity to meet their grandparents before they passed on. Ran into a guy I'd had a crush on when I was a teenager. We married and bought this place and lived happily ever after—at least, until last year when he collapsed and died after a game of tennis."

"I'm sorry."

"Oh, don't be. We had a good life together."

"So what happened to Heavenly Farms?"

"Obviously still producing honey. Other than that, I have no idea and frankly, I don't want to know. I haven't been there since the sixties."

"Is the property still in your family?"

"If it is, it's either April's or June's now."

"Can you give me directions?"

"That I can do."

Back in her room, Salome telephoned Germaine. After the pleasantries, Salome asked, "Would you mind checking with June to see if either she or April owns a place called Heavenly Farms? And if they don't, if she knows who does own it."

"As a matter of fact, I just talked to her last night. Guess what? Her organizer was none other than Honey Lee!"

"Have you told Jude?"

"Not yet."

"I'll give him a call."

Moments later she was on the phone with Judah. "Lee must have stolen June McGann's credit card, the one Duncan Mah sold Saturday night."

"Guess she had the opportunity. Look, let's all meet up tonight, compare notes. I'll round up Germaine, you call Gabe."

"Playing matchmaker, Jude?"

"Who, me?"

"As a matter of fact, Gabe's picking me up at six for dinner."

"Look, I gotta go. The Tombs at eight? Should give you time enough for a romantic interlude."

Feeling restless, Salome paced the room. She had a strong hunch about Heavenly Farms and really wanted to have a look at the place, but it wouldn't be a good idea to go alone.

She punched out the number of Gabe's new cell phone. The noise and music in the background were a pretty good indication he was in a bar.

"It's Mei. You still with Dick Sullins?"

"Nope. We had lunch and that's it. He's on the wagon. Liver problems. Look, I'm over at The Tombs, why don't you join me. We can get a head start on dinner."

"Actually, I'm thinking about driving out to this place outside Alexandria." She then gave him an abbreviated version of her meeting with May McGann. "Are you fit to drive?"

"Of course!" he said with some indignation. "I'll pick you up in fifteen minutes."

Chapter Twenty

ONCE THEY made their way across Memorial Bridge into Virginia, it was another forty-five minutes before Gabe turned east off Route 1, using the directions May had given Salome. They passed through low-income residential areas until the land gave way to a marshy bird sanctuary.

After a mile or so, Gabe turned south onto a dirt road.

The lowering sun shot columns of light through the trees on the west side of the road. The sky had a reddish cast and was already darkening to the east. They passed a fenced area enclosing dozens of beehives and about a mile farther came to a white clapboard church in a small clearing. Behind the church, run-down looking houses were scattered among the heavy brush and trees. A narrow dirt track meandered for about two hundred yards beyond the church, apparently ending at a tall structure that might have been a barn.

"Looks abandoned," Gabe said. Driving farther on, he pulled off the road.

"Why don't you turn the car around and park on the other side of the road?"

"Why?"

"In case we need to leave quickly."

He grumbled, more, she figured, because he hadn't thought of it.

"Park behind those trees."

When he shut off the engine a deep silence descended. They got out of the car and approached the church.

"If we run into anyone we can always say we're pilgrims looking for the house of the Lord."

"Oh yeah, that sounds convincing," Salome said in a low voice, a feeling of unease putting all her senses on alert.

They walked up the worn steps to the church, the peeling paint the first sign that the building was not well maintained, and entered through a single lightweight door. Years of passage through dirt and grit had worn the varnish from the floorboards on the central aisle, along which were battered old pews, misaligned, perhaps twenty on a side. A pulpit stood to the left of the "altar," if an old dining table with a small bronze cross, a plate with hardened white candle wax and a tiny black piece of wick in the center, and a vase of dead flowers could be deemed as such.

The place smelled of must and neglect and something foul like raw sewage. There was no sound and no evidence of electricity, light being provided by small windows on either wall up by the roof. They hurried through the deepening gloom to a door behind the pulpit. Gabe turned the knob. The door opened on a spiral stairway, dark past the first two steps.

"I've got a flashlight in the glove box. Be right back."

He turned and hurried back to the car. Salome pulled her own penlight from her shoulder bag and shone it around the narrow stairway, which curved in a corkscrew fashion—very bad Feng Shui, not that she'd seen any good Feng Shui as yet.

Gabe returned and followed her down the stairs, the fetid smell getting stronger.

"Jesus!" Behind her, Salome heard Gabe sputter and gag. A moment later, at the bottom of the stairs, Salome was slammed by the stench and began breathing through her mouth.

The scene revealed itself in small patches illuminated by their flashlights. They began to hear faint buzzing.

Narrow beds, in tiers of four from floor to ceiling, clung to three walls and in rows down the center of the full basement. There were items of clothing scattered on the floor and on the filthy mattresses. She shone the light toward the source of the

buzzing sound, and taking a couple of steps, found herself looking into a doorless bathroom. Buckets of excrement stood beside an overflowing toilet. A cloud of buzzing flies floated above the miasma. Beyond the curtain of insects, she saw a shower stall; but for a worn patch around the drain, it was black with mold.

She moved to the left and came to a tiny alcove with a sink, a two-burner hotplate on which were two battered aluminum five-quart pots, and shelves on which were stacked plastic rice bowls, cheap cups, and a near-empty bag of tea leaves. In the corner was an empty burlap sack that once held fifty pounds of rice.

"Is anyone here?" she called out, not expecting an answer as the place appeared to have been recently abandoned.

"Salome, I need to get out of here," Gabe called. She heard his footsteps on the stairs. Convinced there was no one in the basement, she followed him outside. She found him leaning against a tree, a pool of vomit at his feet.

"Wait in the car, Gabe. I'll just have a quick look at the other buildings."

Having seen no one in any of the small, dilapidated houses, she moved along the track to the barn. It continued around the side and disappeared into the trees in back. Noticing one of the barn doors was ajar she slipped inside, coming to a wooden barrier about seven feet in height with a Chinese character painted on it. Thin rays of light drifted down from windows high up on the walls. She moved along the barrier for about five feet. Straight ahead were stacks of wooden crates. She turned the corner, astonished by what she saw. She faced a massive desk, behind which stood dozens of man-sized statues of Chinese warrior-priests, replicas of those discovered in some emperor's tomb. Various scrolls hung from the walls featuring Chinese deities.

Salome took another step forward. Her heart nearly stopped when someone grabbed her, someone who had stood in the shadows by the barrier. She felt a hard, callused hand clamp over her mouth and nose and a muscled arm pin her own arms. Then she

felt herself lifted. She kicked and twisted but he had her firmly in his grip. Her nostrils flared as she struggled to breathe.

From off to the right, she heard a toilet flush and water splash in a sink. A moment later, Duncan Mah entered the room. The sleeves of his crisp white shirt were rolled up to the elbows, and he wore gray flannel trousers and an expensive leather belt that matched his shoes.

Surprise flashed across his handsome face momentarily, then he regarded her with cold, malefic eyes. He barked an order in Chinese, and she was marched to a heavy chair with thick leather restraining straps attached to the arms.

"You move or scream, Chang here will snap your neck like a twig," he said in a buttery British accent.

Chang held her head while Mah strapped her arms to the chair. Salome took a welcome breath and hoped it wouldn't be one of her last. She thought of Gabe and hoped he wouldn't stumble into the barn. At the same time, he was probably her only hope of getting out of this situation. Maybe he'd had the presence of mind to call the police and tell them what they'd discovered in the church basement. If she could just keep Mah talking long enough, she might get out of this unharmed.

"Your security stinks."

"Security attracts attention. People become curious, wondering if you are hiding something or maybe protecting something."

"I was referring to Chang. Does he have an aversion to bathing?"

Mah laughed and lifted her braid. "Very nice hair. I could get a good price for it." Then he tossed the braid contemptuously. "Mr. Freeman wouldn't be with you, by any chance?"

"No."

"It wouldn't be prudent to trust you." He said something in Chinese to Chang and walked around the desk. He took a gun from a drawer and gave it to his henchman. Chang moved soundlessly, disappearing around the barrier.

Mah moved around the desk and began filling one of two briefcases open on the desk with papers from a side drawer.

"You had Honey Lee steal June McGann's credit card, didn't you? Seems small potatoes."

"Honey stole far more than a few credit cards. Already a goodly portion of McGann wealth is in a growing account in the Cayman Islands and I shall be joining it shortly. Sale of cards provided spare change."

"And you killed Honey Lee."

He glanced at her. "Oh, I didn't kill her. Chang took care of that chore. I am not a murderer."

"What about the real Duncan Mah? The man whose identity you stole? Who killed him?"

"Chang, of course," he said with a chilling lack of concern.

"What happened to the immigrants?"

"Some headed north, some south. Believe me, there are plenty of people in this country only too happy to hire illegals."

"What are you going to do with me?" Though she did not welcome his answer, she wanted to keep him talking as long as possible.

"Like I said, I am not a murderer. Not that I'm willing to let you live."

"Don't you want to know how I found this place?"

"So I can admire your cleverness? Frankly, I don't have the time, nor do I care. My work here is done." He closed one of the briefcases then the other.

Her heart was beating so fast, she couldn't speak. Salome began an inward chant. *Om ma ni pad mi hum, om ma ni pad mi hum...*

A door at the back of the barn opened. Obviously believing that Chang had returned, Mah smiled. He called out a few words in Chinese and picked up the briefcases.

Salome straightened. Holding her head high, she was determined to conclude her life with some dignity. Then she looked at the figure silhouetted against the late afternoon light in the doorway. Unless he'd grown a few inches in the minutes he'd been gone, this was not Chang.

Chapter Twenty-One

"FBI! LOWER the briefcases and put your hands behind your head," the man ordered.

Mah appeared frozen in place.

"Do it!"

Led by a gun gripped in both hands, he moved quickly into the barn. Salome recognized him as the man she had seen with June the night of the raid at Black Friar's Books.

As Mah slowly set the briefcases on the floor, another agent, his gun also drawn, moved into the room from behind the barrier.

"There's a Chinese man outside with a gun," Salome said.

"We got him," the agent closest to Salome said. "Are you all right?"

"Yes. Would you get me out of this chair, please?"

After putting handcuffs on Mah, the other agent unbuckled Salome's restraints. Helping her out of the chair, he quickly ushered her outside. Salome saw Chang face-down on the ground by a late-model sedan. His hands were cuffed behind his back and he appeared to be unconscious.

"Your friend is waiting at his car. Go on home. And do not talk to the press. We'll be in touch."

He did not appear willing to answer any questions and she did not want to spend another minute in this awful place. Salome ran back to the Mustang. Gabe started the engine as soon as he saw her, his face white with anxiety.

"Jesus! What happened, Mei?"

While he sped off up the road, Salome took a calming breath and told him what had transpired in the barn.

For his part, Gabe said the agents showed up not long after she had left to check out the barn. He urged them to follow her.

"The question is," Gabe said, "how did they know we were out there?"

The answer came later.

Over drinks at The Tombs with Germaine and Jude, and after Salome and Gabe related that afternoon's excitement, Germaine confessed to keeping June informed of Salome's activities.

"I called her after you called me about Heavenly Farms. She must have immediately notified her contact at the FBI."

"She still paying you for information?" Jude asked.

Salome quickly jumped in. "Gabe and I are grateful you called her! I certainly would like to thank her."

"That'll have to wait," Germaine said. "She's on her way to England." Germaine mentioned that June's new boyfriend was a lord and speculated that the pair might be planning to merge their fortunes.

Salome and Gabe left soon after and spent a happy night together at the Georgetown Inn.

A week later, both Salome and Germaine attended a Feng Shui party at the Women's Place. Cake and soft drinks were provided, and each young woman took Salome to her respective room to show her the positive changes they had made. Casey had painted one of her dragon sketches vibrant red and hung it in the fame gua. She also had added color to her wardrobe and wore a new red blouse.

Jane had moved her bed from "the funeral position" in front of the door. The bookcase, less half the paperback romances, had been placed in the relationships gua and featured a framed photo of a cute young man in a bathing suit with a surfboard under one arm.

Kyna had added half a dozen healthy plants to the jade plant Salome had given her.

"Hey, I bet you could do something for our new arrival," Casey said. "She's outside. Her name's Susan Sawyer. She's been here a week and won't speak to anyone."

They passed through the kitchen and into the newly planted garden. A woman with stringy blond hair sat on a bench with her back to them.

She turned as they approached and Salome found herself looking at a familiar face. Germaine looked shocked at first, then snorted derisively, remembering June's presentation at the SOW meeting.

"April?"

"Salome? What are you doing here?" Gone were the glamour and style, the arrogance and spirit. She wore a plain white blouse, jeans, and sandals.

"What are *you* doing here?"

April sighed. "After June told me the FBI had Duncan in custody, I, well, over-served myself. June arranged for me to dry out here." She looked around, then said in a low voice, "These people know me as Susan Sawyer." A spark of familiar arrogance flashed in her eyes. "It's in everyone's best interest if you keep your mouth shut about this. Wouldn't want to incur the McGanns' wrath, now would you?"

That said, she waved her hand in a gesture of dismissal. "I'm vacationing in Europe. Now go!"

Later, during the drive back to Washington, Germaine told Salome about the last SOW meeting and June's presentation of "Susan Sawyer."

"It's clear now that by tailing April, my purpose was to lead June to Duncan Mah. And once he was found, she needed to get her sister out of the way. Fortuitous for June that April has a drinking problem. Makes me mad, though, that she used the Women's Place for her own ends."

Then Germaine smiled slyly. "Still, it'll make great copy for my book."

A couple of times over the next two weeks, Salome and Gabe wondered when the FBI would contact them. But they were too preoccupied with rediscovering each other and redecorating the Malabar Close town house to give the matter much concern.

Then, a couple on a nature hike happened upon the bodies of two Chinese men in a barn at Heavenly Farms. Placed on each body was a white business card with hand-printed Chinese characters. Authorities had the cards translated and learned—or rather believed—that the killings had been gang-related, the Chinese characters referring to a triad operating out of New York City.

Indeed, June McGann had interesting contacts, though not with the FBI.

One night, before drifting off to sleep in Gabe's arms, Salome wondered how things would have turned out had Duncan Mah not chosen to kill Honey Lee, whom she now thought of as the Organizer.

Tracy Smith

About the Author

Like her protagonist Salome Waterhouse, Denise Osborne is a Feng Shui practitioner with many years of study and a firm belief that this ancient Chinese art and science is a viable tool in criminal investigations. Like her other protagonist, Queenie Davilov, Osborne began her professional career as a screenwriter who hit Hollywood fresh from the University of Oklahoma with a degree in motion picture production.

Osborne has written about native American art and artists, received awards for her short films and screenplays, created interactive Web-based characters, and has lived in Japan, England, and Spain. She enjoys giving Feng Shui presentations to various groups around the country and owns Wind and Water House, a studio dedicated to Feng Shui–designed products. She welcomes e-mail and visitors at www.deniseosbornemysteries.com.

MORE MYSTERIES
FROM PERSEVERANCE PRESS
🂡 *For the New Golden Age* 🂡

Available now—

Face Down Below the Banqueting House, A Lady Appleton Mystery
by Kathy Lynn Emerson
ISBN 1-880284-71-5
Shortly before a royal visit to Leigh Abbey, the home of sixteenth-century sleuth Susanna Appleton, a man dies in a fall from a banqueting house. Is his death part of some treasonous plot against Elizabeth Tudor? Or is it merely murder?

Tropic of Murder, A Nick Hoffman Mystery
by Lev Raphael
ISBN 1-880284-68-5
Professor Nick Hoffman flees mounting chaos at the State University of Michigan for a Caribbean getaway, but his winter paradise turns into a nightmare of deceit, danger, and revenge.

Death Duties, A Port Silva Mystery
by Janet LaPierre
ISBN 1-880284-74-X
The mother-and-daughter private investigative team introduced in Shamus-nominated *Keepers*, Patience and Verity Mackellar, take on a challenging new case. A visitor to Port Silva hires them to clear her grandfather of anonymous charges that caused his suicide there thirty years earlier.

A Fugue in Hell's Kitchen, A Katy Green Mystery
by Hal Glatzer
ISBN 1-880284-70-7
In New York City in 1939, musician Katy Green's hunt for a stolen music manuscript turns into a fugue of mayhem, madness, and death. Prequel to *Too Dead To Swing.*

The Affair of the Incognito Tenant, A Mystery With Sherlock Holmes
by Lora Roberts
ISBN 1-880284-67-7
In 1903 in a Sussex village, a young, widowed housekeeper welcomes the mysterious Mr. Sigerson to the manor house in her charge—and unknowingly opens the door to theft, bloody terror, and murder.

Silence Is Golden, **A Connor Westphal Mystery**
by Penny Warner
ISBN 1-880284-66-9
When the folks of Flat Skunk rediscover gold in them thar hills, the modern-day stampede brings money-hungry miners to the Gold Country town, and headlines for deaf reporter Connor Westphal's newspaper—not to mention murder.

The Beastly Bloodline, **A Delilah Doolittle Pet Detective Mystery**
by Patricia Guiver
ISBN 1-880284-69-3
Wild horses ordinarily couldn't drag British expatriate Delilah to a dude ranch. But when a wealthy client asks her to solve the mysterious death of a valuable show horse, she runs into some rude dudes trying to cut her out of the herd—and finds herself on a trail ride to murder.

Death, Bones, and Stately Homes, **A Tori Miracle Pennsylvania Dutch Mystery**
by Valerie S. Malmont
ISBN 1-880284-65-0
Finding a tuxedo-clad skeleton, Tori Miracle fears it could halt Lickin Creek's annual house tour. While dealing with disappearing and reappearing bodies, a stalker, and an escaped convict, Tori unravels the secrets of the Bride's House and Morgan Manor, which the townsfolk wish to hide.

Slippery Slopes and Other Deadly Things,
A Carrie Carlin Biofeedback Mystery
by Nancy Tesler
ISBN 1-880284-64-2
Biofeedback practitioner/single mom/amateur sleuth Carrie Carlin is up to her neck in snow, sex, and strangulation when her stress management convention is interrupted by murder on the slopes of a Vermont ski resort.

REFERENCE/MYSTERY WRITING
How To Write Killer Fiction:
The Funhouse of Mystery & the Roller Coaster of Suspense
by Carolyn Wheat
ISBN 1-880284-62-6
The highly regarded author of the Cass Jameson legal mysteries explains the difference between mysteries (the art of the whodunit) and novels of suspense (the hero's journey) and offers tips and inspiration for writing in either genre. Wheat shows how to make your book work, from the first word to the final revision.

Another Fine Mess, **A Bridget Montrose Mystery**
by Lora Roberts
ISBN 1-880284-54-5
Bridget Montrose wrote a surprise bestseller, but now her publisher wants another one. A writers' retreat seems the perfect opportunity to work in the rarefied company of other authors…except that one of them has a different ending in mind.

Flash Point, **A Susan Kim Delancey Mystery**
by Nancy Baker Jacobs
ISBN 1-880284-56-1
A serial arsonist is killing young mothers in the Bay Area. Now Susan Kim Delancey, California's newly appointed chief arson investigator, is in a race against time to catch the murderer and find the dead women's missing babies—before more lives end in flames.

Open Season on Lawyers, **A Novel of Suspense**
by Taffy Cannon
ISBN 1-880284-51-0
Somebody is killing the sleazy attorneys of Los Angeles. LAPD Detective Joanna Davis matches wits with a killer who tailors each murder to a specific abuse of legal practice. They call him The Atterminator—and he likes it.

Too Dead To Swing, **A Katy Green Mystery**
by Hal Glatzer
ISBN 1-880284-53-7
It's 1940, and musician Katy Green joins an all-female swing band touring California by train—but she soon discovers that somebody's out for blood. First book publication of the award-winning audio-play. Cast of characters, illustrations, and map included.

The Tumbleweed Murders, **A Claire Sharples Botanical Mystery**
by Rebecca Rothenberg, completed by Taffy Cannon
ISBN 1-880284-43-X

Keepers, **A Port Silva Mystery**
by Janet LaPierre
Shamus Award nominee, *Best Paperback Original 2001*
ISBN 1-880284-44-8

Blind Side, **A Connor Westphal Mystery**
by Penny Warner
ISBN 1-880284-42-1

The Kidnapping of Rosie Dawn, A Joe Barley Mystery
by Eric Wright
Barry Award, *Best Paperback Original 2000*. Edgar, Ellis, and Anthony Award
nominee
ISBN 1-880284-40-5

Guns and Roses, An Irish Eyes Travel Mystery
by Taffy Cannon
Agatha and Macavity Award nominee, *Best Novel 2000*
ISBN 1-880284-34-0

Royal Flush, A Jake Samson & Rosie Vicente Mystery
by Shelley Singer
ISBN 1-880284-33-2

Baby Mine, A Port Silva Mystery
by Janet LaPierre
ISBN 1-880284-32-4

Forthcoming—

Crimson Snow, A Hilda Johansson Mystery
by Jeanne M. Dams
The murder of a popular schoolteacher shocks South Bend, Indiana. Young
Erik Johansson was in Miss Jacobs's class, but his sister Hilda, housemaid to
the prominent Studebaker family and preoccupied with her pending marriage,
refuses to investigate this time—until Erik forces her hand. Based on an un-
solved case from 1904.

Paradise Lost, A Novel of Suspense
by Taffy Cannon
Appearances deceive in the kidnapping of two young women from a posh Santa
Barbara health spa, as relatives and the public at large try to meet environmen-
tal ransom demands, and the clock ticks toward the deadline.